The
Photographer's
iPad

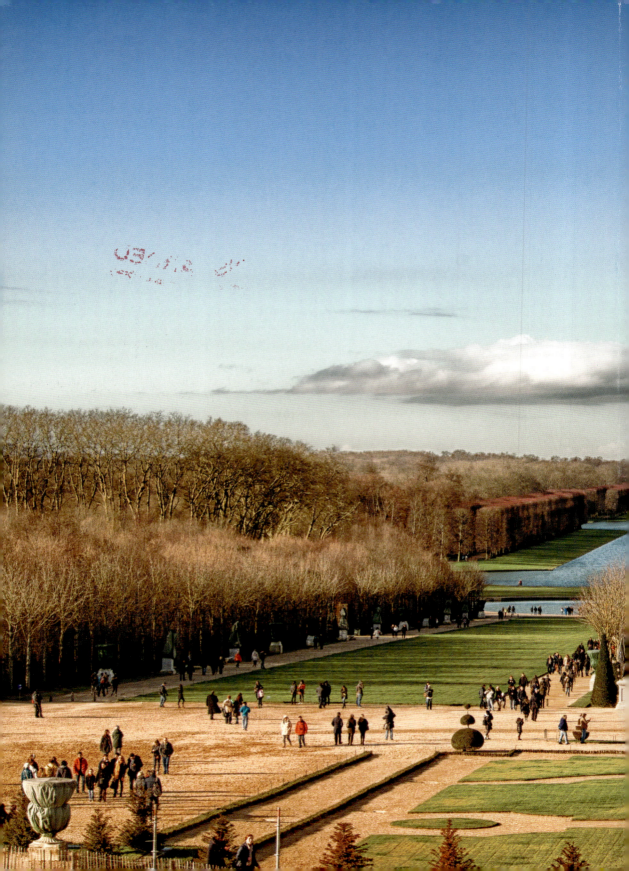

FRANK GALLAUGHER

The
Photographer's
iPad

ilex

An Hachette UK Company
www.hachette.co.uk

First published in the UK in 2015 by
ILEX, a division of
Octopus Publishing Group Ltd
Carmelite House
50 Victoria Embankment
London, EC4Y 0DZ
www.octopusbooks.co.uk

Design, layout, and text copyright
© Octopus Publishing Group 2015

Distributed in the US by Hachette Book Group
1290 Avenue of the Americas
4th and 5th Floors
New York, NY 10020

Distributed in Canada by
Canadian Manda Group
664 Annete St., Toronto, Ontario
Canada M6S 2C8

Publisher: Roly Allen
Commissioning Editor: Adam Juniper
Editor: Rachel Silverlight
Senior Project Editor: Natalia Price-Cabrera
Art Director: Julie Weir
Design Concept: Grade Design
Designer: Ginny Zeal
Senior Production Manager: Peter Hunt

ISBN 978-1-78157-226-9

A CIP catalogue record for this book
is available from the British Library

Printed in China

Introduction

For a long time I was frustrated with the iPad. Sure, it was really cool to play around with the touch interface and admire high-resolution images on the retina screen, but the novelty wore off, as it tends to, and I wanted to do more. Apple certainly promoted it as a creative tool, so why was it such a hassle getting my photos onto it, not to mention editing them?

Some of that had to do with the limitations of the early iPads, and a lot of it had to do with Apple's walled-garden approach to its operating system (in which Apple carefully manages its ecosystem and doesn't allow a lot of open-ended functions and features), but all of that has changed now. Today's iPads are as powerful as many "proper" computers, and Apple has finally seen the light (at least glimmers of it) and begun opening up iOS to developers in a number of ways that give me control over where my files are, and where they're going. Even then, it's not always clear how to achieve what I want. In writing this book I can't tell you how many times I banged my head against my desk, trying to figure out why a certain menu item was grayed out, or where an image was actually being saved to.

But I figured it out, for the most part, and here I've put together a workflow that will not only help you make the most of your iPad, but will also, I hope, augment your photography. That's a pretty big claim to make, I know, but hear me out.

Mobility isn't just a nice thing to have in photography; it's a fundamentally important aspect of our art. Whether you're shooting a compact camera or a full-frame DSLR, it's part of our ethos as photographers to go where we need to be to get the shot, and the less encumbrance toward that end the better. Of course, the images don't stop at the camera either, and as advanced, connected, and WiFi/Bluetooth/NFC-enabled as our modern cameras are getting, for serious photography, there's still a critical step between capturing an image and sharing it: the computer.

Well, you can now leave the laptop behind for the vast majority of your shooting needs. By the end of this book, you'll feel confident in your ability to import and organize photos in the field, edit them using professional-quality tools, sync all this with your main image library back home, and share your images at any step along the way. Plus there's video editing and studio shooting thrown in for good measure, because, well, the iPad is impressively useful in those situations as well.

My goal is to map out this workflow as simply as possible, to make it abundantly clear how to achieve what you want, whether that's uploading your photo to a specific outlet, or achieving a particular look in editing. I fully expect that before you know it, the iPad will become one of your most important pieces of gear for achieving and sharing your creative vision.

► Pro tip: polarized sunglasses help cut through the glare of an iPad screen in sunlight.

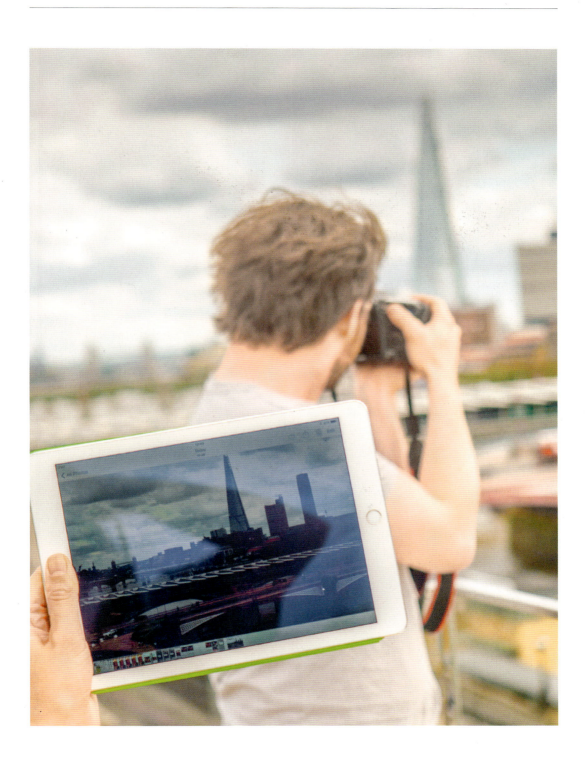

Getting Started

Before we jump into the deep end, it's important to get everything set up properly. The first time I set up an iPad, I just tapped Yes and OK as many times as necessary until I could finally play with the thing, but recognizing what these initial steps are doing will come into play later on.

Also in this chapter I'm going to try to manage your expectations from the outset. I don't want to ever sound like just another advertisement—you've already paid for the iPad, I don't have to convince you to buy it again. I do, however, want to make clear the inescapable limitations of the device, as we'll be working within (and, in some cases, around) these limits throughout the rest of the book—don't worry though, there's more than enough exciting material to cover.

Finally, we'll end with a visual overview of this iPad workflow I keep talking about. Workflow is a techie term for the step-by-step process of doing what you want with your images in the optimal way. You already have a workflow whether you call it that or not (assuming you've ever moved photos off your camera); so in many ways this is an addendum, or an elaboration on your already-existing methods, that incorporates the iPad and all its extra abilities.

These pages assume this is your first iPad; if you're upgrading from a previous version, skip to page 12.

So, first off—congratulations! You probably just had your own personal unboxing ceremony, and you're ready to get started. This may seem a bit remedial, as Apple has made it very simple and straightforward to set up this device, but many people are curious about what exactly each setting does along the way, so I'll begin by spelling it all out so that it's crystal clear. I also have a couple recommendations that you might not expect.

It's also worth noting that you really can't do this wrong. If you want to go back and sign out of iCloud, you can do that at any point. Want to change your password or update your TouchID? No problem at all. Basically all these settings are found in...wait for it...the Settings menu! This menu is quite cavernous, with loads of different configurations and setup options. Rather than detail the whole thing here (which would take a whole chapter), I'll be referring to specific submenu options throughout the book, as and when you may need to reference them.

▲ You're first prompted to choose a Wi-Fi network. If you don't have one available, don't worry, you can plug the iPad into a dedicated computer and set it up through iTunes.

▲ I strongly recommend enabling Location Services—it's what allows location-based apps and websites to determine your location (super handy in a variety of ways).

▲ As this is your first iPad, you'll be selecting the first option—Set Up as New iPad.

▲ And if this is your first Apple product, you'll need to set up an Apple ID. You'll use this every time you get an app from the App Store (whether it's free or not!).

◄ I also strongly recommend enabling iCloud. It's a service that Apple's put a lot of effort into making worthwhile over the last few years, and is handy in all sorts of ways—see pages 36–39 for more info.

▲ Next you'll be asked to set up your TouchID (iPad Air 2 and later) and to Create a Passcode. This may surprise you, but I don't have either of these options set up on my iPad. My iPhone? Yes. Macbook? Definitely. But personally I don't use my iPad in ways that need that security—it just makes it a bit more difficult to get it started. But this is, of course, a personal preference.

▲ I find Siri not nearly as useful on the iPad as I do on the iPhone, but sure, why not; it's nice when you need it.

► Here I recommend checking Don't Send, because I'm not sure what information is being transmitted, and even if I did, a new set of Terms & Conditions would change that tomorrow.

◄ And voila voila! You're all set and ready to go! Also, this is the first time you get to see the weird way Apple refers to the iPad (that is, they don't call it "the iPad," but rather just "iPad." I think that's really awkward so throughout this book I'm going to be using the definite article "the." Sorry, Steve!

If you're upgrading your iPad from an earlier version to the latest and best, setting up is a simple process. The first step is backing up your old iPad, which can be done either in iTunes or via iCloud. I prefer iTunes as it's quite a bit faster, and doesn't intrude on your iCloud storage; but either way works fine. Once your old iPad is backed up, simply turn on your new iPad, select a Language/ Region and a Wi-Fi network (as per steps one and two on the previous pages), and you'll be prompted with the option to Restore from either an iCloud or an iTunes backup.

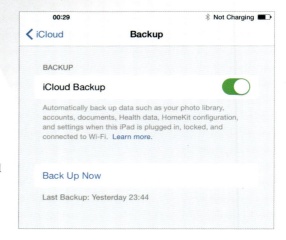

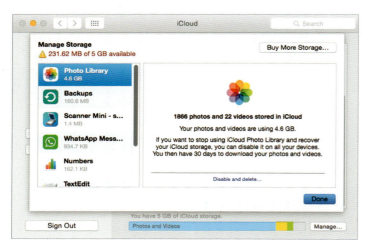

▲ iCloud backup is reached via the Settings menu. Scroll down to iCloud, then tap on Backup. Here you'll also see the option to automatically back up to iCloud periodically, which is handy, so long as you have space in your storage.

◄ You can check how much storage you have remaining in your iCloud anytime on your Mac, by going to System Preferences > iCloud and clicking on Manage... at the bottom right. This is a handy interface that let's you see exactly which Apps are using your iCloud space, and how much each one is taking up. You can also sort through older backups and delete outdated ones.

Note: Simply put, iCloud wants your photos. If you enable Backups, it will store your photos and videos along with your other data. The only way not to have those (inevitably large) media files included in your backup is to enable iCloud Photo Library (page 38). But that means your photos and videos are already being transferred to your iCloud (they're just not technically part of the official Backup service). It's rather annoying, as it's possible you could want to use your iCloud Backup only for data and not for Photos. If you're wondering the motivation for this setup, look no farther than the Buy More Storage... button at the top right of the Manage iCloud Storage screen!

Backups

Automatically Back Up

◉ **iCloud**
Back up the most important data on your iPad to iCloud.

○ **This computer**
A full backup of your iPad will be stored on this computer.

☐ **Encrypt local backup**
This will allow account passwords and Health data to be backed up.

Change Password...

Manually Back Up and Restore

Manually back up your iPad to this computer or restore a backup stored on this computer.

| Back Up Now | Restore Backup... |

Latest Backup:
Yesterday 23:44 to iCloud

▲ When you back up in iTunes, the files are stored on your desktop—specifically, in your Library folder under Application Support > MobileSync > Backup.

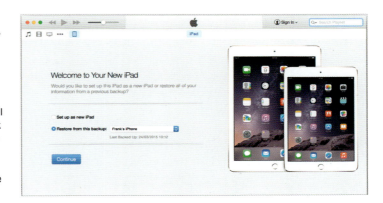

▶ Once your old iPad is backed up, you can plug in your new one, and iTunes will prompt you with this window. Simply click Restore from this backup, and select the version you want to restore. When you select a Restore option, a progress bar may hang for quite some time—don't be impatient! Restoring can take a while.

iPad Mini vs Air vs Pro: While all want the newest tech, this book is explicitly written to be model-agnostic. That said, obviously the first-generation iPad will struggle a lot more than more recent models (in fact, older models don't support the latest iOS releases, so even if it runs the app, it will all look different). Broadly speaking, if your iPad has a retina screen, it should be able to handle everything this book throws at it. Later models will, of course, benefit from their better processors and run faster, but for the most part, they should all work fine.

▲ It's worth pointing out that while the iPad Pro is certainly the top of the line, it's not a barrier to entry. Pro owners will certainly see performance benefits across the board—better resolution display, faster performance, and better responsiveness with the Apple Pencil. But personally I still enjoy the Air models—they strike a better balance for me between performance and portability.

What You Can Do with Your iPad

Let's start by mapping out in broad strokes the things at which the iPad is clearly optimized for, at least from a photographic perspective. You can...

CAPTURE

The most obvious way to capture images with the iPad is, well, to use the iPad's camera. The "rear-facing" camera (on the back) is surprisingly decent when used in well-lit conditions. It's a clumsy unergonomic mess, but it gets the job done, and I discuss this on pages 24–25.

The far more interesting method is to control your camera from the iPad itself. More and more cameras these days include built-in Wi-Fi as a feature, which can be paired with a dedicated iPad app offering various degrees of control of the camera. This method of capture, called tethering, used to be reserved for professional equipment in a studio setting. No longer! If you're doing still-life or product photography, it's really a remarkable ability to preview your shot on a full-size, high-resolution screen before ever even taking the shot—not to mention the other perks of being able to remote control your camera. This is all discussed in detail on pages 116–117, but needless to say, it's a powerful tool to have at your fingertips.

VIEW

Again, this is a bit obvious, but worth elaborating on. The iPad's retina screen is class-leading and frankly stunning. With pixel dimensions of either 2048x1536 (Mini and Air), or 2732x2048 (Pro) these screens have more resolution than even most top-of-the-line desktop monitors. The key feature is how densely packed those pixels are: between 264 and 326 pixels per inch (ppi) depending on your particular model. The (Apple-promoted and science-backed) idea is that at this pixel density,

the human eye (with ideal 20/20 vision) is unable to resolve the individual pixels at a normal viewing distance of 13 inches (33cm). OK, the specs are boring; the point is that it's a state-of-the-art viewing platform, and brings an enjoyment to reviewing photos that is acutely absent from staring at the LCD on the back of your camera.

That enjoyment is, I think, a critical component of what makes the iPad so valuable. As we'll see, there are many tasks that are technically easier to do on a desktop, but—combined with portability—the simple joy of reviewing photos encourages you to take care of administrative tasks while you're out and about, with the day's shoot still fresh in your mind. You can evaluate fine detail very easily, spotting blemishes and focusing errors often without even having to zoom in. And while the iPad may struggle in some ways to match the performance of a desktop, when it comes to reviewing, tossing out the rejects, rating the winners, and so on, iOS's gesture controls are more than adequate. This leads on well to the next topic...

EDIT

Later on, I'll distinguish between organizing (Chapter 3) and editing (Chapter 4), but both are part of the comprehensive and professional post-production workflow. The sheer portability of the iPad just begs for it to be an in-the-field tool, and you'll see that it very much can be—up to a point. It performs what's called "photo triage" very well: you can get photos off your SD card and backed up to a safe place; organize your photos into albums, collections, etc.; apply metadata and keywords, and rate and tag your images so that by the time you start the actual processing stage of your workflow, you're already done with the nitty gritty. However, there are limitations, which are elaborated on the following pages.

But that's just speaking to professional standards. There are also myriad photo-editing apps that let you apply special effects and filters with (frightening) ease, and that's definitely part of the fun of the iPad. My favorite among these is Snapseed, which I discuss on pages 70–77, but there are many many more out there. I particularly see value in these apps when traveling—for those times that I don't need to make a print-quality final image; rather, I just want to touch up a shot and show people where I am and what I'm doing, which leads to...

SHARE

The fact that with a few taps and swipes, you can broadcast your photography to a huge array of outlets only seconds after the image is taken speaks to the photographic value of the iPad (and will be very familiar to anyone with a smartphone).

▲ Be warned—the ability to quickly review shots on a full-screen iPad will make your camera's LCD feel rather inadequate.

► Keep an eye out for this Share icon. You'll see it everywhere, and its functions change dynamically based on which app you're in at the moment. For instance, in the native Photos app, you can Share directly Flickr, Facebook, or Twitter, or put your selected image(s) in a message or email; whereas more advanced apps like Photosmith let your Share to like Dropbox or even package an XMP export.

The camera manufacturers are desperately trying to catch up to this capability, and often failing wildly at it. One of my goals throughout this book will be to bridge the gap between your camera and iPad as seamlessly as possibly so you can get your photos where they need to be as fast as possible, regardless of what your particular outlet of choice may be.

What You Can't Do with Your iPad

This may be the last thing you want to hear if you've just purchased a brand new iPad, but it's important to understand the limitations of the device if you want to make the best use of it—and avoid headaches when you try to accomplish the impossible. You can't...

MANAGE FILES NORMALLY

The iPad notoriously does not have a file manager. It's not simply a matter of clicking and dragging files from the SD card into an import folder. At times, you'll be shocked just how little control you have over your files—various apps will rename the files, strip out EXIF data, create copious duplicates, refuse to cooperate with anything but basic JPEGs, and so on. If you were to never leave the native Photos app, maybe this wouldn't matter, but that's no way to live your life! Fortunately for you, I've been inside and out of every app discussed in this book, and I'll warn you about what is and is not

possible every step of the way, offering an ideal workflow in each case. But for now, the important thing to recognize is that when you're working on the iPad, you have to throw out your normal ideas about file management. This is particularly covered in my discussion of the Photos app on pages 48–49, and Dropbox on pages 42–45.

COLOR MANAGE YOUR PHOTOS

The iPad doesn't honor ICC (International Color Consortium) color profiles, choosing instead to treat every image as if it were in the sRGB color space. This is by far the most common color space, in use throughout the internet, so the decision does make a certain sense (and frankly, color management is honestly the most tedious part of any photographic workflow—sorry printers!). If you've never heard of color profiles before, you won't even notice it. Just make sure that you're capturing images in sRGB originally, and the rest takes care of itself. I'll also point out whenever you need to be aware of this in particular apps and editing programs.

◄ You're going to get very accustomed to looking at this screen! In the Photos app on the iPad, you can organize your image and video files into different Albums. But unfortunately, each app has the tendency to create its own dedicated album, which can quickly make this screen a mess. As you move between apps and export edited files, you'll quickly have multiple versions of the same file in different albums. You can only rely on Apple so much; it's up to you to keep this space properly organized.

► All three of these shots are screengrabs directly from the iPad, showing exactly what I saw. The top image is embedded with an sRGB color profile, and is very accurate to what I worked on in my color-calibrated monitor.

► This shot is embedded with an AdobeRGB color profile. You can see some of the hues are being pushed outside the displayable gamut. Now this is tricky, because were I to print this photo, I would certainly want to do so in an AdobeRGB color space, as that offers a wider gamut. But if you're incorporating an iPad into your workflow, it's best to change to that color profile and do final color adjustments at the end, just before you print. Otherwise you just can't trust what you see on the screen.

► And just to drive the point home, this is the same image embedded with the ProPhotoRGB color profile. Wow.

WORK EASILY WITH RAW FILES

Notice I said "easily." iOS is perfectly happy to import Raw files from every major camera (if your brand-new camera isn't supported, just check for iOS updates; the next release should offer the required Raw support); you'll be exhilarated to open up the Photos app after an import and see all your Raw files fully viewable, and even with an Edit button next to them—but don't be fooled! What you're looking at is in fact just an embedded JPEG, and often not even a very high-quality one at that. It's important to remember that when you're looking at photos on the iPad, you are always looking at only a JPEG—with the notable exception of dedicated Raw converters like PiRAWnha (pages 78–81) or when working in Lightroom Mobile (pages 58–61, though even then it isn't a real Raw file, as you'll see).

You'll very quickly see that I'm a dedicated Raw shooter. I would always rather deal with extra storage and lengthy processing times than have anything less than optimal data to work with when it comes time for post-production. Therefore, at every step of the way through this book, I've insisted on at least preserving original Raw files. There's still plenty of in-app edits and sharing of JPEGs to be done, but when it comes

time to extract every last detail from my images, I like to have the original Raw file to work with.

I won't press my preference upon you, though; rather, I'll just lay out the basic options. Of course, it does get even more complicated than this—for instance, you can shoot Raw+JPEG but never import the Raw files to the iPad, instead keeping them on the card until they can be imported to your desktop. Additionally, not all JPEGs are created equal—if you're using a tiny, highly compressed JPEG just for reviewing and tagging on the iPad, it's really just a stand-in for the Raw file itself, never intended to be edited or shared.

◄ You'll need to take your intent into account. If you're taking snapshots that you have no intention of ever printing, or that you never plan on intensely editing for every last ounce of detail, then sure, JPEG is fine. Personally, I find that I'm almost always "just" taking snapshots until suddenly (and unexpectedly) I'm shooting a really amazing subject at just the right time and in fantastic light. On those blessed occasions, I'm thinking about a million things other than diving into my menu system and switching from JPEG to Raw. In short, it's better to be safe than sorry.

The Case for JPEG: JPEGs are by far the most universal file type for photos. Every camera is capable of capturing and outputting images in this format, and the iPad will read them without any problem. They work by compressing redundant areas of color and tone throughout the image, as well as by reducing the bit depth to 8-bit; what that means is the files are small and can therefore be transferred/imported/exported quickly and easily (and using up a minimum of bandwidth if you're using a data plan). In short: it's easy.

The Case for Raw: Ultimate digital malleability. You can extract every bit of information from your images—recover lost highlights, sharpen without artifacts, balance tonality without worrying about banding, and fine-tune the white balance without any loss of data. Indeed, the entire Raw workflow is "Non-destructive," meaning that no matter how much work you do on the image, the original file remains completely undisturbed. In short: it's comprehensively professional.

The Case for Raw+JPEG: You'd expect me to say that it's the best of both worlds. On the one hand, it is, clearly. But on the other, it makes for a more complicated workflow. You'll be juggling two files for each image rather than one, with the intention of marrying them back together at some later point when you import to your desktop (ideally via Lightroom). But if you follow the instructions throughout this book, this may be just the iPad workflow you're looking for. Just pay attention to which file is where and you'll be fine.

Creating an iPad Workflow

It's extremely useful to have at least a basic mental map of your image workflow. It should be a very simple checklist that you run through each and every time you finish a shoot, so that you know exactly which images are where, and what can be done to them at each stage of the process.

CUSTOMIZING YOUR OWN APPROACH

I've worked on many, many different books about digital-image workflow, and let me tell you—there is no single, authoritative method. Quite the opposite, in fact. The best method is something that feels natural to you, and which you arrived at organically, so you reliably adopt it as a matter of habit. Of course, there are nevertheless broad outlines to go over:

CAPTURE, THEN BACK UP: If you're in the field, you'll need some other external storage option for your backup. The point of a backup is redundancy—having multiple copies of your files, so that if anything happens (say, you lose your iPad), you don't lose everything that was on any one particular device. You could use your memory card as a secondary backup, but a) then you can't use it to shoot anymore (not a huge problem on short trips in the field), and b) tiny memory cards are even easier to lose!

IMPORT TO IPAD: What sounds like a simple step actually gets quite a bit of attention in the following chapter. As you'll see, there are a great many ways to import photos onto you iPad. I'll discuss the various wireless options later on, but when it comes to building your ironclad workflow, I prefer to use the dedicated SD-to-Lighting adapter.

RATE & TAG RAW FILES: This is, of course, assuming you have Raw files to rate and tag; if you're JPEG-only, then you will lump in this Rate & Tag step with the Edit & Share step below.

This may seem unimpressive at first, but I can't tell you how many hours I've saved by rating and tagging a shoot while sitting on the train, waiting in an airport, even relaxing in a cafe. This is a tedious step, but an absolutely essential one. First, there is nothing in the world better than a well-tagged image library. It makes the process of sorting through tens of thousands of images an order of magnitude easier; if you're a professional, it's expected that you'll be able to quickly find exactly the right type of shots based on a well ordered keyword system. Likewise, rating your shots now means that when you get back to your dedicated computer, you can jump right into editing the cream of the crop, and save storage space by tossing out the obvious rejects immediately. I'll show you all about how to work with these Raw files on pages 58–59.

EDIT & SHARE JPEGS: This is easily the funnest part of the iPad workflow. As you'll see in Chapter 4, there are plenty of competent apps that offer professional editing functions with intuitive user interfaces. If you shoot JPEG-only, these are the beginnings of your real edits. If you shoot Raw, you can still pull out a mid-sized preview, though that's better for quickly highlighting some of your best shots so that you can share them while you're still in the field.

IMPORT TO DESKTOP: And once you're back, you can properly import all your images into your photo library. You'll see later on that your Ratings and Tags have been carried over, giving you a head start on your next steps.

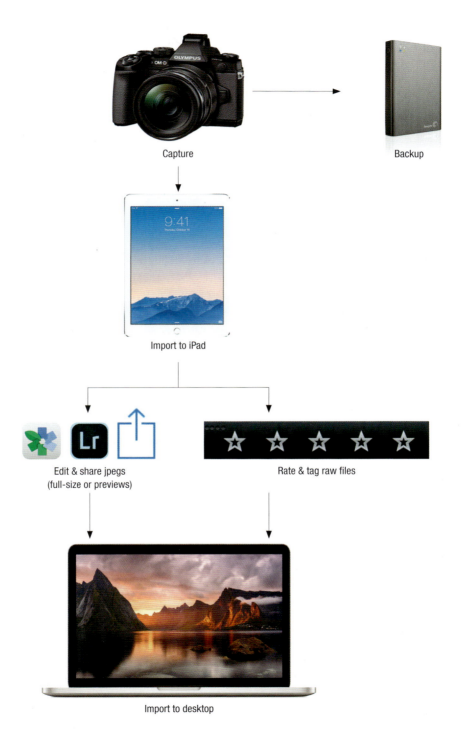

Capture

Backup

Import to iPad

Edit & share jpegs
(full-size or previews)

Rate & tag raw files

Import to desktop

Importing Photos

Now that we're up and running, it's time to wrap our heads around how files work on the iPad and in the iOS ecosystem. We'll start by taking a good look at the iPad's camera, since it's the easiest way to get photos onto the iPad (and the one Apple assumes you'll use the most). Then we'll talk about our dedicated cameras, and how to import our photos from their SD cards, be it wired or wirelessly.

Then we'll take a look at the cloud—which is just a fancy word for the internet. iCloud in particular can be confusing at first, especially once you start adding photos from a non-iOS device (your camera). You'll have a much easier time if you understand what Apple's trying to do, and then use those services to your own ends.

By the end of this chapter, you'll have no problems moving photos (and other files) between your camera and your iPad, and then onward from there.

The Camera App

Smartphones have cameras and so tablets must as well. Two, in fact—a main rear-facing camera and a lower-resolution front-facing camera, mostly intended for video chat.

HOW GOOD IS THE MAIN CAMERA?

It's not great. Sorry, just being honest. But when I say that, I'm holding it to some pretty high standards. We're photographers, after all, and so I think it's important to stick to the facts and know our gear. Toward that end, regardless of your iPad version, the 35mm-equivalent focal length is always somewhere between 30–35mm, and aperture is permanently stuck at around ƒ/2.2.

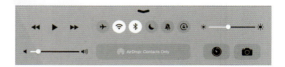

▲ The camera app can be launched directly from any screen, including the lock screen, by just swiping up from the center bottom of the screen, and tapping on the Camera icon at the bottom right—much faster than hunting down the app amid all the others on the main screen.

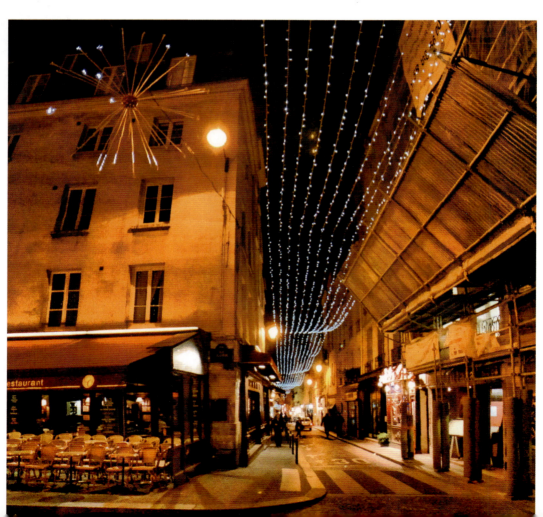

At the very top of the menu bar is the option to switch between the front and rear-facing cameras. Keep in mind that the front-facing camera is of lower quality, and the HDR feature isn't available.

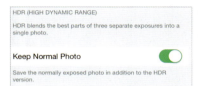

The HDR feature is the real deal, not just a gimmicky filter. It takes a bracket of two exposures and combines them into a final image that manages to retain detail in both the shadows and the highlights. When activated, it will default to Auto mode, which is very good at activating only when a particularly high-contrast scene is detected. The HDR image will be saved to your Recently Added folder, and if you check Keep Normal Photo under Settings > Photos & Camera, it will save a normally exposed photo as well.

Here, you've got your four shooting mode options. The basic Photo option is discussed at length on the following pages. Square is the same as Photo, just pre-cropped. Other options include Time-Lapse, Slo-Mo, Video, and Pano. It's worth noting here that video crops the field of view quite heavily—almost to about 50mm.

◄ Despite what I say, the iPad's camera image quality may surprise you sometimes. This night shot was taken at ISO 1250—well above what I recommend using. It's noisy and lacks fine detail (from the Noise Reduction), but as a snapshot from a cafe table, it works.

With iOS 8, Apple finally introduced a timer feature in the Camera app. It's pretty basic, with options for a three- or ten-second delay, but it's better than nothing. When one of these options is selected, pressing the shutter button will initiate a countdown which will be displayed large and centered on the preview display. Apart from the obvious use of using this for selfies and group photos, using the three-second countdown is an excellent way to cut down on blur caused by camera movement, particularly if you're bracing the iPad against something and shooting in low light.

SO WHEN CAN I USE THE CAMERA?

Absolutely any time you wish! All I mean to say is that of all the truly exceptional features packed into the iPad, the camera is just another camera. But I will readily admit that it's very fun having a Live View screen as big as the iPad when you're composing a shot—it's like looking at ground glass while using a large-format camera!

▲ We've all seen it—an iPad screen precariously held up above a crowd, the screen completely filled with glare and useless for composition, capturing a small stage event or bit of action quite some distance away using a 31mm-equivalent wide-angle lens. I know the best camera is the one you have with you, but I take that as encouragement to always have a dedicated camera on me, rather than to force the iPad's camera into situations where the cards are stacked against it.

► In Settings > Photos & Camera, there are two options. The Grid will split the screen into a grid of nine rectangles, which aids in composition a great deal, so I recommend activating it. The second option comes into play when you take an HDR shot—it will save a normal exposure in addition to the HDR image. I find this just fills up the Photos folder with redundant, usually inferior images, so I keep in deactivated.

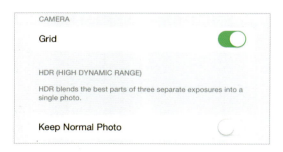

► The iPad's camera will automatically lock focus and exposure once the frame settles on a scene, indicated by the appearance of orange framelines on the focus point. But tapping on the screen will move focus and exposure to that point, and the box will be slightly smaller (and thus more accurate). More importantly, a small sun icon will appear to the right of the box—that's your exposure control. Focus will remain locked, but you now have exposure compensation control!

◄ Swiping up is positive exposure compensation. You can swipe up anywhere on the screen—you don't have to press on the Sun icon.

▲ But be warned, swiping up is naturally going to start pushing the limits of the camera's capabilities. Remember, you're starting from what the iPad thinks is a proper exposure. In this crop, you can see that the only way to add exposure compensation was by dropping the shutter speed, which has now introduced motion blur. If you look close, you'll also see that noise is appearing in the shadows—there's really not much dynamic range in this sensor, especially at anything but base ISO (50).

Third-Party Camera Apps:

There are other camera apps that offer features that the native app does not (yet, anyway—Apple has a habit of taking the best of these apps and incorporating them into the native app in future updates). **Manual** is designed for real photographers, as it gives you direct control over the ISO and Shutter Speed (Aperture is always locked). It also gives you a live histogram. **Camera Plus** is a long-time favorite, with a variety of useful features, such as a tilt warning and an extra-large shutter button. **VSCOcam** is another popular one, offering a lot of specialized controls of its own, but also linking together with its own very talented and creative photo community, making sharing fun.

◄ Sliding down gives negative exposure compensation, which is just what this shot needs, and a perfect example of when you may want to override the iPad's autoexposure (though, to be fair, the iPad picked a pretty great balance of highlights and shadows to begin with, it's just that I want a proper silhouette for this shot). Negative exposure compensation will also bring the exposure back into the comfort zone of the sensor when shooting scenes with a wide dynamic range.

▼ And would you look at that! Not bad at all, especially for straight out of the camera. A bit of editing and this is a shareable shot. 1/120 second, f/2.4 at ISO 32.

MAKING PANORAMAS

This is one part of the iPad's camera I absolutely love, as my dedicated camera can't even make in-camera panoramas. Lots of new cameras can, but in my experience even they don't have the processing power to line them up nearly as seamlessly as the iPad.

▼ The process is very easy: Switch the shooting mode to Pano, and a guideline will bisect the screen, with a thumbnail of the starting image on the left. By default, you should rotate the iPad from left to right, but to reverse that, just tap the thumbnail. Line up the shot, press the Shutter button, and slowly rotate the iPad on its central vertical axis (don't rotate your body—this is the trick to a quality pano). Keep the arrow centered on the guideline, and when you're done, tap the Shutter button again.

Importing from a Card

The first and most important accessory to purchase for your iPad is the Camera Connection Kit (CCK). Which type will depend on both your iPad version and whether you use SD cards or CompactFlash. I strongly caution against getting an off-brand version of the CCK—I've used them, and they are extremely unreliable. Whether that's because Apple has some proprietary ingredients in the mix of their own device or not, I can't be sure, but regardless, it's one of the cheapest products Apple makes, and well worth it. Start keeping it with your iPad and camera gear just like any other piece of equipment—you'll be using it plenty!

▲ The CCK is a very simple plug-and-play device. In my experience, it's best to insert the SD card into the slot first, then insert the other end into the Lightning adapter on the iPad.

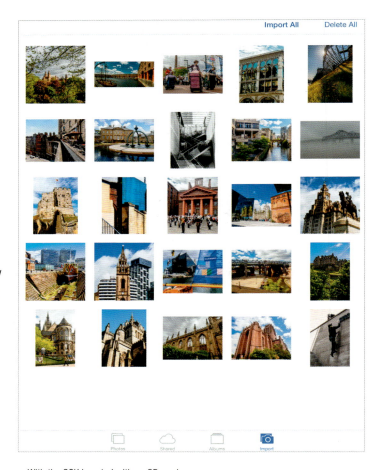

▲ With the CCK inserted with an SD card, open up the Photos app, and you'll see a new Import icon at the bottom right. Tap that, and you'll get a preview of all the images on the card. You can quickly tap Import All, or be more meticulous and select only those you wish to import.

The USB Camera Adapter:
Technically meant only for directly connecting a camera to the iPad, this is a useful piece of kit. It can be used to connect a USB keyboard, a microphone, a MIDI or other audio device, and so on. The catch is that the iPad provides only minimal power, so it won't work with all devices. Some manufacturers list the compatibility of their devices, but in my experience, it's a trial-and-error experience. It's worth noting that the iPhone is compatible with the USB Camera Adapter; just plug in the iPhone's USB cord to the adapter and import away!

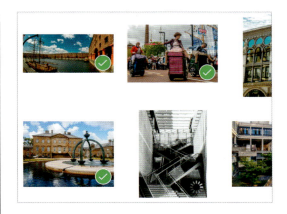

▲ As the Photos start being imported, they'll gain a small green check mark at the bottom right of each thumbnail, allowing you to track the progress. The import will continue in the background if you have other work to attend to.

► And at the end, you'll be given the option to clear the card. I strongly urge not to do this—check that all the images were properly imported first. Even then, I prefer to format the card only within the dedicated camera itself.

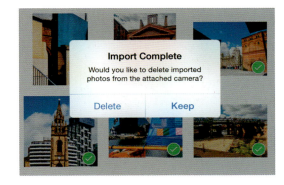

◄ Returning to the Albums view, you'll see the photos were added to the All Photos album, and can also be found in a dedicated Last Import album.

Almost every new camera has

built-in wireless these days. Their functionalities vary wildly, but all of them allow you to wirelessly connect a mobile device to the camera in order to transfer images. It's an incredibly handy feature, as you don't have to carry (and risk losing) the Camera Connection Kit while out in the field. The WiFi capabilities often also include remote control of the camera's shooting as well (i.e., wireless tethering), but that's covered later on in pages 116–117. I could spend this whole book detailing how each manufacturer's products and apps work with the iPad, but there's one product that is similar and works regardless of camera model.

EYE-FI MOBI

Eye-Fi makes a range of SD cards that, in addition to storing image files just like any other memory card, broadcasts its own WiFi signal from the card itself. This allows even cameras that don't have built-in WiFi the ability to transfer photos wireless to the iPad. The Mobi version can save Raw and video files just fine, but it transfers only JPEGs. I've used other, more expensive cards before, ones which support Raw transfer, but as you'll see, I find that for a wireless workflow, you really just want to be dealing with JPEGs—Raw and video files are best dealt with on a dedicated computer anyway, and they take ages to move wirelessly.

◄ When you open the Eye-Fi Mobi app, you'll be prompted to enter the Activation Code that came with the Eye-Fi card. It's an important code, as you'll need it any time you set up a new device, or if you ever have to reinstall the app, so I recommend keeping it very safe—or better yet, take a photo of the card case with the code printed on it. Save the photo titled Eye-Fi Activation or something like that, and then you'll be able to find it in your photo library whenever you need it.

Install Profile

Cancel | Install

◄ Once the card is activated, you'll be prompted to install a WiFi profile on the iPad. If your iPad behaves anything like mine, it may warn you that it's an unauthorized profile, or throw up some other security warning of some sort. I've never had the slightest problem using Eye-Fi products, so just accept and approve whatever messages pop up, and install the profile.

► With the profile activated, the SD card in the camera, and the camera broadcasting its WiFi signal (which may need to be enabled in a camera menu setting), your iPad will be able to connect to the Eye-Fi network, and the Mobi app will give you a notification when the connection is secured.

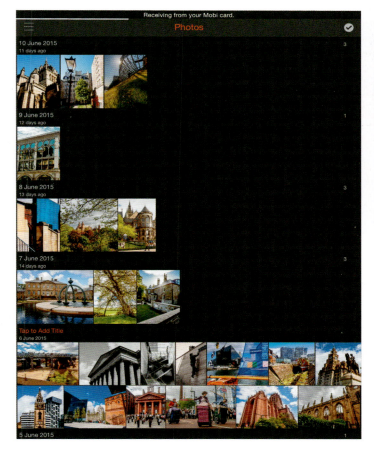

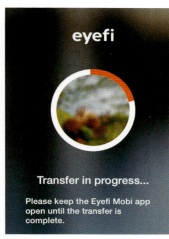

▲ At that point, the app will automatically start importing any and all JPEGs it finds on the card. You'll need to keep the app open and in the foreground for the duration of the transfer, which is indicated by a circular progress bar.

◄ You'll also be able to watch thumbnails of the transferred photos as they appear in the app.

Don't worry, if your camera has its own WiFi capabilities, the proprietary app almost certainly works very similarly to Eye-Fi's. It may be even slicker—many allow you to establish the connection using QR codes or via NFC (Near-Field Communication), which makes the previous pages irrelevant. But even in the proprietary apps I've used, once the photos are transferred, they often still don't appear in the native Photos app, so you'll need to export or save them locally in a manner probably similar to this.

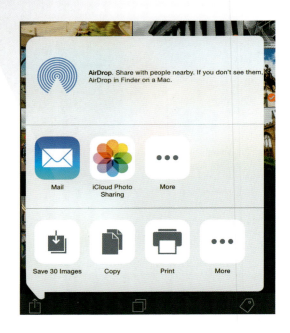

► In almost all cases, once all the images have been transferred to the app, you'll want to select them all, tap the Share icon at the bottom left, and save them to the Photos app. This might sound strange, but the image files are stored discretely in the Mobi app, separately from the Photos app, and the two apps don't communicate to each other. It's one of the quirks of the iOS environment, but trust me, you'll get used to it!

▲ Once you save the images, they'll appear in the Photos app in two folders: All Photos and a new Eyefi album. Don't worry, there's only one version of the file; the All Photos album will always contain the contents of every other album.

► ▼ But before we leave the Mobi app, there are a couple other features that are worth noting. While viewing a single image in full screen mode, you can tap on the i icon (second from the left) to pull up the EXIF data for that shot (right), which is difficult to find elsewhere, and impossible to find in the Photos app. If you tap on the icon in the center, you can start adding tags to the photos, which will transfer along with the photos throughout the rest of your workflow (something to do while you're waiting for the transfer to finish). And lastly, in the gallery view, if you select two photos, you'll enable a Compare icon in the menu bar (second from the left). Tap it, and you'll pull up a comparison view. I'm a huge fan of this feature, and really wish it were included in other apps more often.

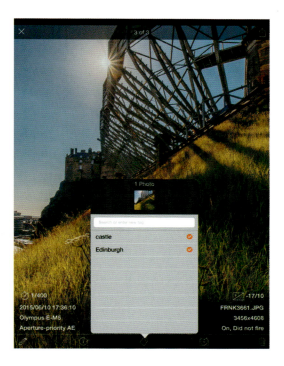

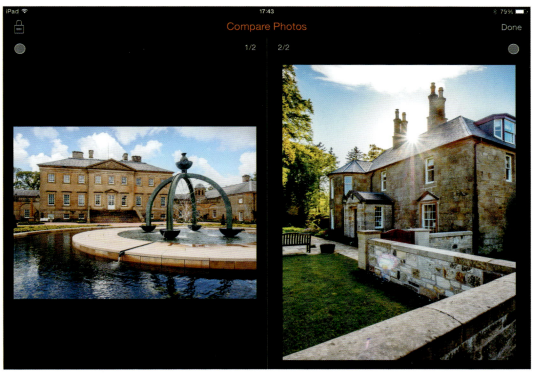

iCloud

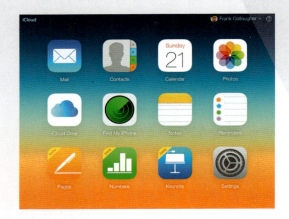

▲ iCloud is many different things in different places. This is the website you see after going to iCloud.com and signing in using your AppleID.

Apple has had its own cloud

computing service since way back in 2000, but it's been branded many different things over the years: iTools, .Mac, MobileMe, and now, iCloud.

SO, WHAT DOES IT DO?

A whole lot, in fact. iCloud is used for a variety of services offered across Apple products, from Find My iPhone (which applies to the iPad as well, as we'll see on the following page), to iTunes Match, to iWork and more. But for now, we're going to look at the dedicated photo services, which are plentiful but rather complicated.

STORAGE

The purchase of any Apple product gets you 5GB of storage free, but that applies only to your first product. You can buy 30 iPads (who knows, maybe

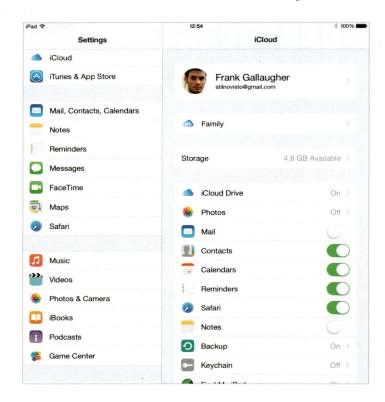

◀ Once again we return to the Settings menu. What you see here is dependent on a few other settings—particularly if you have upgraded your storage plan, you'll see more than my meager 4.5GB of available space!

you want a multimedia art installation or something), but you'll still only get that first 5GB. Hypothetically you could register each device to a new and separate Apple ID, but then that defeats the whole purpose of syncing the data across all your devices. That 5GB goes very quickly, but the subscription costs for upgrading to a larger storage capacity aren't too pricey, and are bound to go down over time. So if you find you really like iCloud's services, it may be worth considering making it your go-to online storage center. But first let's see how it works.

SETTING UP ICLOUD

Go to Settings, and scroll down on the left column to iCloud. Once you enter your AppleID details, you'll see a list of options that can be turned on or off; you'll see Photos second from the top (clearly an indication of its relative importance). I strongly recommend you activate Find My iPad at this point. All the other options are entirely up to you (it really depends on what you want to use your iPad for—activating everything can clutter up your workflow at times). But the Find My iPad feature works extremely well, and you'll really want it if you ever lose your device.

► The first step is to activate the iCloud Photo Library. This will automatically upload to iCloud photos not just from your iPad, but also from any other synced Apple device. You can even directly upload photos to iCloud from a browser, and they will then proliferate from there across any other device that is synced to your iCloud Photo Library (a very handy feature at times).

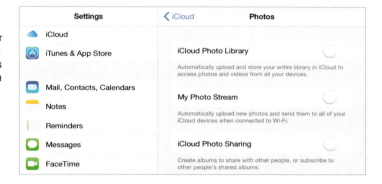

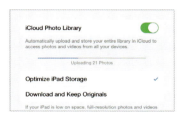 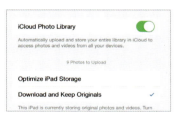

◄ Of course, all these photos take up space, and regardless of whether you upgraded to the biggest-capacity iCloud storage plan or purchased the top-of-the-line iPad, if you're not careful, you'll quickly fill up both with gobs of high-res photos. Toward that end, Apple gives you the option of Optimizing your iPad storage, which will keep track of your remaining space, and dynamically replace full-resolution files with low-resolution ones as you start filling up your memory. Personally, I don't like the lack of control that offers, and if I'm going to be editing anything, it needs to be the high-res original, so I prefer to have Download and Keep Originals checked.

Note: Once you activate your iCloud Photo Library, the Camera Roll folder on your iPad will be replaced with All Photos. It's confusing at first, but it makes sense, because the photos in that folder are no longer necessarily taken by the iPad camera. It's everything, regardless of capture device origin, in one spot.

PHOTO LIBRARY VS. PHOTO STREAM

Photo Stream is a feature that predates the iCloud Photo Library. When it's activated, it automatically uploads either the last 30 days of photos or the most recent 1000 photos you've taken, whichever is greater. These photos are then proliferated across all your Apple devices.

If this seems redundant with the Photo Library, that's because it is. Photo Stream is a legacy feature that works with pre-iOS 8 devices, and pre-Yosemite OSX Macs. For that reason (and knowing Apple's history in this area of relentless and often-forced upgrades), I don't honestly think Photo Stream is long for this world; it's likely to get phased out at some point. It was a very cool feature, and a bit ahead of its time, but it's basically been replaced with Photo Library. The notable distinction is whether you think the last 30 days of photos you've either taken or uploaded to your iPad totals more than 5GB. If it's more, then Photo Stream is actually a better deal, because it's free, and it doesn't count against your iCloud storage allotment. But it doesn't offer the flexibility of the Photo Library. Namely, it uploads only low-resolution versions, doesn't support video files, and won't notify you when files are removed and lost forever (whereas iCloud will tell you loud and clear that your storage capacity has been reached and oh, hey, would you like to upgrade to a larger-storage subscription?).

So, I'll leave it up to you as to whether you want to enable Photo Stream. Perhaps you have older devices that won't interact with the Photo Library, or perhaps you're fine with it storing low-resolution copies and have your own back-up plans for the high-res files. But if you want my advice, keep Photo Stream off, and just count on Photo Library. Apple is basically bullying us into doing this, and it's much easier to follow their lead.

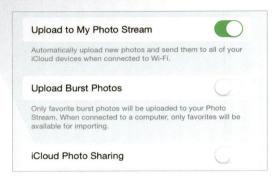

▲ There are three additional On/Off features in the Settings > iCloud > Photos menu that are worth addressing (described on these pages).

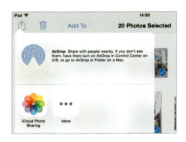

▲ From any album of photos, you can select as many as you like, and then click the Share icon at the upper right, where you'll be prompted with the iCloud Photo Sharing option.

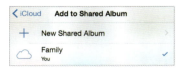

▲ From there, you can add them to any existing Shared album, or create a new one.

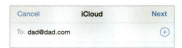

▲ ▶ You can then enter as many email addresses as you like, and send an invite to the album, along with a brief message.

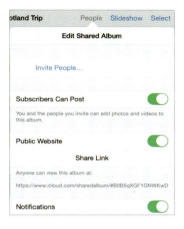

▲ Once you enable iCloud Photo Sharing in Settings, a third Shared option will appear at the bottom of your Photos view on the iPad.

▲ While viewing the created Shared album, you can tap People at the top right, and enable Subscribers to edit the Album themselves. Most usefully, you can also create a public-facing website for the album, with a link that can be shared with anyone—even non-Subscribers (thought they won't be able to edit the album unless you've properly invited them.

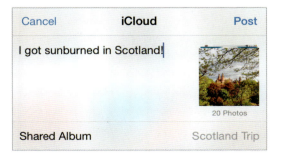

UPLOAD BURST PHOTOS

Don't! The iPad can shoot ten photos per second, at full resolution, and that will fill up your iCloud storage insanely fast if you keep all of them. Such high burst rates are very cool, but it's well worth choosing your favorite of the set after the fact and discarding the rest. Even if you have tons of space, it's always wiser to choose the best of a Continuous-Drive burst sequence shortly after shooting it; few things are more tedious than cycling through 20 images in Lightroom that are 99.5% identical and trying to select the best shot. I wish I could have those hours of my life back!

ICLOUD PHOTO SHARING

This is a nifty feature that lets you create and share a public photo album. The album supports JPEG, TIFF, PNG, Raw formats, and even video files (up to five minutes long and 720p resolution). You can invite as many people as you like, and those "Subscribers" can even add or delete photos of their own, if you allow it (see left). It's also not limited to Apple users—anyone can join.

While this is primarily meant for the sharing of family vacation albums and the like, there's also a great amount of collaborative opportunity in these Shared albums. A group in a workshop can post all their images from the day in one place, you can share images with a client and allow them to delete the shots they don't want—lots of possibilities.

AirDrop

Since iOS 8, we're finally able to transfer files between Macs and the iPad. It's an unbelievably helpful feature that saves so much of the tedious work that used to entail importing/exporting using various parts of iTunes. AirDrop works via Bluetooth, meaning the two devices don't even need an internet connection (though, for whatever reason, WiFi does need to be activated). You can share photos, videos, music, iWork docs, notes, contacts, directions and location data. It's also compatible with a variety of third-party apps—basically wherever you see the Share icon, you can use AirDrop. It's just swell.

This is specifically the direction in which Apple is moving with most of its products: discard the wires and use WiFi, BlueTooth, or a combination whenever possible. The transfer speeds are slower than a dedicated Thunderbolt connection, but that's more than made up for in the convenience.

AirDrop isn't particularly useful in the field. It's more about saving time when you're back at your desk and want to move files around effortlessly—whether that's edited files from your iPad to your Mac, or adding a batch of files from your Mac to your iPad for editing in your favorite app.

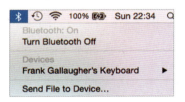 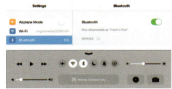

◄ First, make sure you have Bluetooth and WiFi enabled on both your Mac (far left), and iPad (left— you can activate WiFi and Bluetooth either in the Settings menu or in the Control Center by simply swiping up and tapping the Bluetooth icon, third from the left).

AirDrop Tips:
- ➔ The iPad needs to be running iOS 8 or later, and the Mac Yosemite or later.
- ➔ It works only for iPad 4th Generation or later, and Macs 2012 or later.
- ➔ You can transfer extremely high-resolution images that even the Camera Connection Kit won't normally recognize.
- ➔ Works for Raw files as well.
- ➔ It may surprise you how many non-image file types are supported as well. If there is a default app, the file will automatically open there. Otherwise, you'll be prompted with a list of options.

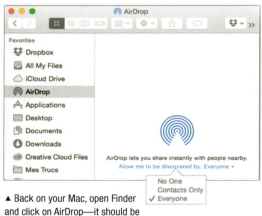

▲ Back on your Mac, open Finder and click on AirDrop—it should be anchored under Favorites on the left-hand menu bar. Once there, you'll have the option to set your public-facing options: No One, Contacts Only, or Everyone. As nothing can happen via AirDrop without the approval of both parties, I tend to leave it on Everyone. It's a very safe feature.

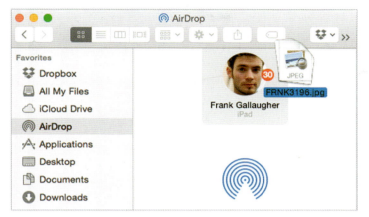

Frank Gallaugher
Sending...

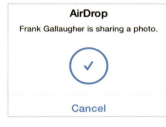

▶ ▲ Once it's all set up, your iPad (or another contact) will pop up in the AirDrop Finder window. From there, you can click and drag photos and files to transfer to the iPad just like moving files around in Finder (above left). Once the transfer begins, a circular progress bar will initiate (above).

▲ And on the iPad, you'll get a notification first, and then a similar circular progress bar will initiate. When the transfer is complete, it turns into a checkmark. Photos will be transferred directly to the All Photos folder—this doesn't count as an import, so there won't be a Last Import album created. And voila voila! No wires, no adapters, no memory cards.

AirDrop Troubleshooting:
→ Turn off any personal hotspots.
→ Make sure bluetooth is activated on both devices.
→ If you're transferring between iOS devices, both must be signed into an iCloud account.
→ The iPad must be activated before it will show up in Finder's AirDrop window on the Mac. Once the transfer is in progress, it will continue in the background.
→ It can sometimes take a while for your Mac to find your iPad, and vice versa. If you're moving files from the iPad to a Mac, it helps to have the Finder window open on the Mac. Patience is a virtue!
→ Double check that you're allowed to be discovered by Everyone—this has a habit of being reset, particularly following an iOS update.

Dropbox

So far, despite the numerous methods we've discussed for moving files from one place to another, we've never actually interacted with a file structure of any sort. You know, the Folder > Subfolder structure that makes up the entirety of your dedicated computer's file system? That structure exists somewhere in the iPad, but we don't have access to it. And so we talk about Albums and Collections and "transferring between apps," but these are just workarounds for what would normally be a click-and-drag simplicity.

DROPBOX AS FILE MANAGER

Dropbox is a versatile app that can fill the gap of the missing file manager. At its heart, Dropbox is just a drive, like any other. It sits on a server in a warehouse somewhere, and you have access to it via a folder—just a simple folder. On your Mac,

it lives on your desktop and is called simply Dropbox. You can drag files into and out of it just like any other folder, you can create new folders and subfolders, and you can open files within Dropbox, edit them, and save them. Simple, right?

The great part is that this folder is 100% mirrored on your iPad in the Dropbox app. Every file, every folder, every adjustment made on your desktop is sent to that drive sitting in a warehouse, and then relayed on to your iPad (which is a funny thought, but that's how "the cloud" typically works—you have to go around the world to move from your computer to your mobile device sitting a few inches away).

▼ Tapping on the Photos icon at the bottom left will scan through all Folders and Subfolders in the Dropbox and pull them into one nice, organized gallery view.

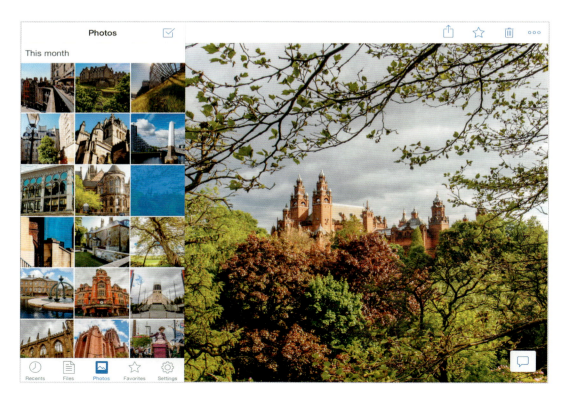

► Tapping on the Files icon shows what's going on under the hood. All these image files were exported from Lightroom directly to my Dropbox folder back on my Mac. They're sitting in Finder just like they're sitting here on the menu bar along the left side. All I had to do was open the Dropbox app on the iPad, connect to the internet, and the files automatically started downloading (the Dropbox folder was "syncing" with the iPad—it will continuously sync itself across devices that are online).

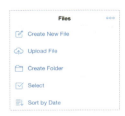

▲ The discreet little three dots at the top of the Files menu opens up these options, each of which give dedicated file-manager type control over the images (or file types of any sort) that are sitting in your Dropbox.

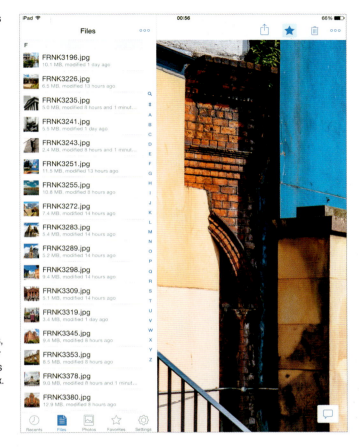

◄ While Dropbox has excellent integration with iOS, it's still a third-party app, so it won't connect you with Notes, Numbers, or Keynote; you'll need to have their Microsoft-equivalent apps installed on the iPad. Nonetheless, it's handy to be able to create a new file from scratch.

► This is the super-handy place where you can upload files from elsewhere on your iPad (say, your All Photos album) to Dropbox. You can even pick an entire album from Photos to upload. Additionally, if you have other file types on your iCloud Drive, you can upload them as well. But you'll be using the Upload Photos option much more often.

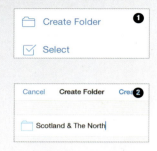

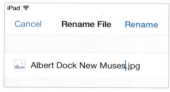

▲ And in the same drop-down menu discussed on the previous page, you can even create new folders within the Dropbox. Tap on Create Folder (1), and you'll be prompted to name the Folder (2). Then go back to the drop-down menu and tap Select (3), which will bring up a list of checkboxes next to each of the files in the Dropbox (4). Tap which images you want to move to the new folder, and then tap Move. The screen will then swipe over to the list of new folders (5), where you can tap on the new folder, swipe over to it, and then tap Move again at the bottom right (6).

▲ It seems like quite a few hoops to jump through, but it really is one of the more efficient methods I've seen for moving files around via a tablet interface. And the coolest part is watching the changes appear in Finder as your Mac syncs up! Of course, the point is to be able to do this when your away from your desk.

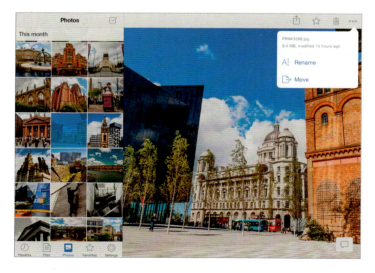

▲ It's also very simple to rename files. From either the Files or Photos view, just select one file and tap the three dots at the top right of the preview, then tap Rename in the drop-down menu. This is a handy last step before sharing the file—many sharing sites will preserve the filename regardless of what caption you write, and FRNK3298.jpg just doesn't have that great a ring to it.

SHARING FROM DROPBOX

While this is slightly outside the scope of this chapter (which is all about getting files onto the iPad), it's worth detailing Dropbox's Share abilities. They're excellent, and I rather prefer gathering together photos that I've edited or organized in some other app, moving them to Dropbox, and sharing from there rather than using the other editor's native Share function.

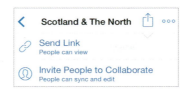

▲ From a subfolder, tapping the Share icon gives you two options for sharing multiple images at a single time—very handy.

◄ Tapping Invite People to Collaborate lets you make that subfolder public. This can be a powerful tool when working with others on a project, and, of course, it remains editable and viewable regardless of which device you're using, including a dedicated computer.

► The other option is to simply generate a hyperlink, which can then be AirDropped, emailed, or simply copied for further use in another app. The link will go to a gallery where others can view and download the full-resolution images, but they won't be able to edit the existing photos, or upload photos of their own.

◄ Tapping on the Settings icon pulls up a few more options. Most helpful is the ability to see the Space Used—if you intend on using Dropbox's free allotment of space, you'll need to keep it regularly cleaned out, as files have a tendency to build up especially if you're mainly using Dropbox just to move files from one place to another. Once the file is where you need it to be, remember to go back and either delete the copy from Dropbox, or move the original to a safe place on a dedicated computer or hard drive.

You can also set a separate Passcode lock just for Dropbox, though I think this is a little over the top. And finally, you can use the Carousel feature to automatically upload all your images to your Dropbox, where they'll be displayed in a pretty decent gallery app. Your call on that one.

Sharing vs Saving: It's a bit counterintuitive when you need to move files from Dropbox to your All Photos folder (remember, they're both on your iPad, but in separate places; also, Dropbox will keep only a low-res copy locally until you either zoom in to expand or make it a Favorite). To save the full-res file to your Photos folder, you first click the Share icon, which usually means sending it elsewhere. But then you'll be prompted with a Save Image option, which is the Share icon flipped vertically. Well, at least their design philosophy is consistent!

Organizing Photos

Somewhere around my fifty-thousandth photo, I got serious about managing and organizing my image library; I suggest you get around to it sooner. And the iPad really helps with this—it's a joy to review photos on the retina screen, and the touch interface is a great way to interact with your images.

We'll start by returning to the Photos app, because Apple recognizes the importance of organizing photos, and has a number of features both automatic and manual to help you. Then we'll pull out the big guns and thoroughly review the Photosmith app, which is as professional as it gets at this stage. It's an essential piece of a proper iPad workflow; nothing else really comes close (so, if you can't tell, I highly recommend it, and it's well worth the pricetag). We'll also be setting ourselves up for chapter 5 by seeing how Photosmith can sync up with Lightroom.

The Photos App

Apple seems to make a point of overhauling its Photos app with every new iOS update, but it's finally settling into a definite workflow. That's helped in no small part by the abandonment of iPhoto and Aperture—it's all Photos now, on iOS and OSX alike. The idea is that as long as you have your iCloud Photo Library set up, what you see on your iPad will mirror what you see in the Photos app on your Mac.

▶ To create a new album, tap the + sign at the top-left corner of the Photos app. You'll be prompted to enter a name for the album.

▼ Next, simply select which photos you want to add, and tap Done. Usually it's as simple as going to the Last Import album and tapping Select All.

HOW DOES IT WORK?

Photos is basically the hub for photography on the iPad. Apple wants all your photos to live here, first and foremost. Other apps will have to ask permission to access Photos in order to organize, edit, and share them. And in most cases, when you're done editing an image in another app, Photos will create an album just for that app and return the image back to Photos.

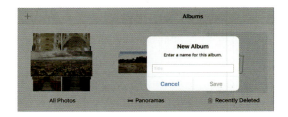

This may sound restrictive, but a) that's all part of Apple's walled garden, and b) it works pretty well most of the time. You'll see in a moment that there's a much more comprehensive way to organize images (that allows for rating, tagging, syncing with Lightroom, etc.), but for casual imports and edits, it does the job.

When it comes to organization, you're either putting photos in albums, or "favoriting" them by tapping the heart icon in the toolbar while viewing a particular photo (which, itself, then creates an album called Favorites).

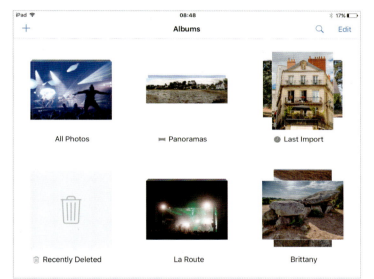

◀ ▲ Albums are the traditional option for organizing your photos. You'll always have a default All Photos album, as well as a Recently Deleted album (which will keep your images safe for 30 days, unless you manually permanently delete them). The Last Import folder will be generated after your first import, and will update itself after each new import. The Panorama album is automatically created when an image of particularly wide dimensions is detected—and it doesn't have to be created using the iPad (or iPhone) Panorama camera function (see page 29).

▲ ▶ Counterintuively, the Photos tab at the bottom of Photos is the less traditional option for organizing. It's split into three sub-categories: Years, Collections, and Moments. It's Apple's approach to organic and automatic organization, grouping together what its software reckons are single events, or trips, or—as they're called—brief moments. In practice it's rather unpredictable; it works better with photos taken on the iPad (or iPhone), but seems to be hit or miss in interpreting imported images. Nonetheless, it can be helpful in sorting through large batches of images.

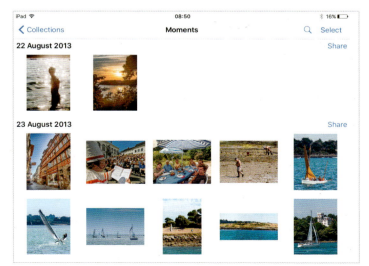

Photosmith

Photosmith takes image organization to a professional level. This is where you can really get to work organizing your images while you're still in the field, so that they're 100% ready to go when you get back home. And best of all, when you're back at your desktop, you can sync the collection you've created in Photosmith directly to Lightroom. I really can't stress how beneficial this can be—it's one of the biggest time-saving tools the iPad has to offer for a working photographer.

IMPORTING FROM THE PHOTOS APP

If you've already imported photos into the Photos app (see previous pages), then you have two options for how to get them into Photosmith: copying or linking. Copying means exactly that—the image files are copied from the Photos app into the Photosmith "sandbox." Linking means the original image file remains in the Photos app, and Photosmith merely links to it to render full-sized JPEGs for its purposes.

Copying the files will double the amount of memory, and that can quickly eat up your storage allotment; but Photosmith themselves say it's the "safer" option, as it puts the image file completely within the Photosmith ecosystem. Linking is simply a space-saving tool. If I'm not planning on importing any more photos before I get back to my desktop, and I have the space for it, I choose to copy the files. But I've never really seen a big performance hit by choosing Link either.

Photosmith Capabilities:

→ Directly import images from the camera via WiFi, completely separately from the Photos app

→ Render Raw images natively (rather than using embedded low-resolution JPEGs

→ Apply Ratings, Labels, Flags, and Keywords, with a lot of customizability to accomodate your particular workflow habits

→ Preserve that above-mentioned metadata with the image file when it's later imported to your desktop

→ Filter large batches of images via a range of criteria

→ Auto-organize images into Smart Groups via a simple slider

→ View full EXIF data for each image, including an RGB histogram

→ Export options to Dropbox, Facebook, Flickr, and email

→ And best of all: Sync your images directly with your existing Lightroom catalog

◀ Whether you want to Copy the photos or Link them, your first step is to tap Import at the top right of the main screen when you first open the app.

◀ In the subsequent pop-up window, tap Settings to choose which method you prefer.

► Also in the Import Settings menu, you'll be able to select when to use Photosmith's Raw processor to generate new JPEGs. The type of JPEG embedded in your Raw files depends on the camera manufacturer, and possibly on which settings you've selected on the camera itself. Photosmith needs a full-sized JPEG, so here you have the option of telling it whether to Always render a new JPEG, Never render one, or do so only When Needed. When Needed is the best option—it's never steered me wrong, and it's a big time saver.

▼ Once you're done in Settings, tap back to Photos to make your selections and begin to import. I'm using the same album I created on previous pages, so importing is a simple one-tap action. If you're making particular selections though, it helps to adjust the slider at the bottom so you can select as many or as few images at a time as you want.

Decode RAW:

✓ When needed Always Never

Note: If you choose to Link rather than copy, be sure not to delete the original photos in the Photos app. That app has no idea what Photosmith is doing, and won't give you any warning; but Photosmith themselves say that doing so can cause "Very Bad Things" to happen (their capitalization, not mine).

It's also worth pointing out here that when it comes time to sync with Lightroom, Photosmith will use the original full-resolution image files from the Photos app, so there's no cost there.

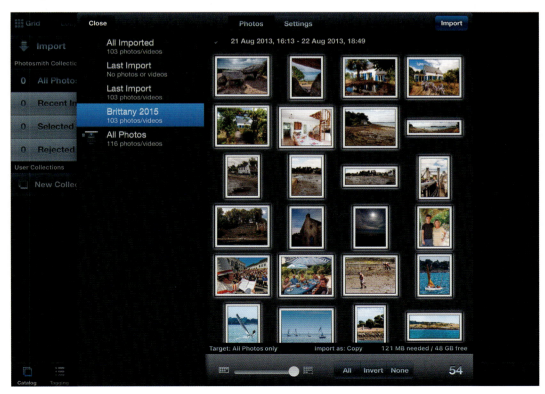

IMPORTING DIRECTLY VIA EYE-FI

If you're using an Eye-Fi card (see page 32), you can skip the Photo app altogether and import directly into Photosmith's sandbox. I really like this method because a) I think doing things wirelessly is really neat, and b) it declutters my workflow. I won't have redundant and vestigial image files on my iPad leftover after I've organized them in this totally separate app. And of course, if at any point you do want to have the capabilities of the Photos app (or any other app, for that matter), you can always export from Photosmith to Photos.

Funnily enough, I find importing via Eye-Fi even easier from Photosmith than from Eye-Fi's own app. All you have to do is connect to the card, and the photos will start streaming in on their own. And voila voila! Just like that, you have all your images saved in a dedicated Collection, ready for organization!

◄ For the sake of simplicity, I'll show you only the toolbars you need to interact with for each step:

1) At the bottom left of the screen, tap on Dashboard to bring up a new toolbar.

2) Tap Eye-Fi at the top, just under Import Configuration.

3) Select which card type you're using (Photosmith recommends the Mobi— see my note opposite).

4) Select which User Collection you wish to import the photos to. You can create a new one by tapping on the right arrow if you haven't already created one. I also highly recommend checking "Continue to run when app exits," as the import process can be lengthy. This is the part where you'll be reminded to connect to the Eye-Fi card's Wi-Fi network. Once it says it's connected...

5) ...images will start streaming into your Catalog, and you can monitor the process in the Activity window that pops up.

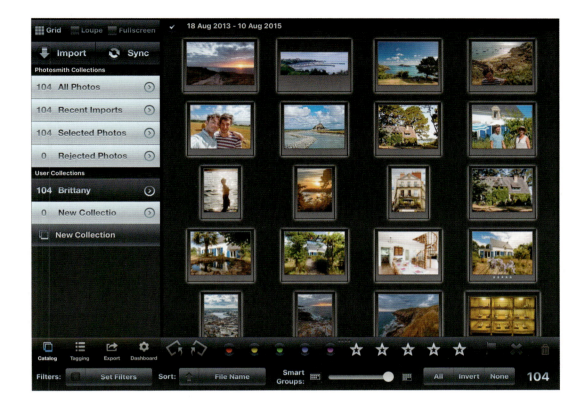

▲ This is the main grid view, giving you a broad overview of your entire collection. You can drill down by switching to Loupe or Fullscreen views, or by activating a filter of your choice.

Note: You may notice that by using the Mobi card, I'm only working on JPEGs; the Raw files are left behind on the SD card. Worry not—all your tags, flags, stars, and other means of organization can be married back up with the Raw files when they're imported into Lightroom later on, as I detail on pages 58–59.

Of course, this really only works if I've shot Raw+JPEG. If you shot Raw only, you'll have to import into Photos first, then Copy or Link to Photosmith.

Likewise, even if you shot Raw+JPEG but want to clear out and re-use that SD card before you get back to your desktop, you'll want to import the whole lot into Photos first (as well as backing up to an external drive, because you're doing that as a matter of course, right?).

RATING & FLAGGING

With your photos imported, you'll default to the Catalog view. Here, you have three different options for viewing your Collection: Grid, Loupe, and Fullscreen. And in all three views, you'll have the QuickTag bar running along the bottom.

▲ Your viewing options are found up at the top-left corner.

▼ At first you'll see only half of the QuickTag bar, but if you swipe up on it, you'll reveal a second set of features.

▲ You'll also note that the second set of features in the QuickTag bar changes between Catalog view (where it's all about organization) and Loupe & Full Screen view (where it's a filmstrip to help you navigate).

▼ When you want to switch out
of Fullscreen view, just tap Done.

At this point, I'm usually eager to get a good look at the day's shoot, so I'll tap on Loupe to switch to a larger view. The EXIF data runs along the top, and includes the filename, date, camera model, lens, resolution, focal length, shutter speed, aperture, ISO, and—my favorite—an RGB histogram.

Now comes the fun part of reviewing the shoot. I tend to swipe through the entire shoot, to give every photo at lease a cursory glance. The normal pinch-and-zoom function works here, and you can double-tap for a quick 100% magnification (if it looks horribly pixelated at first, just give it a couple seconds; Photosmith might be rendering a larger view). I'll switch between Fullscreen and Loupe views depending on my curiosity as to the EXIF data, and—most importantly—start rating and tagging. Obvious rejects gets Xed, the best of the best get Flagged, and I start my (incredibly subjective and personal) system of ranking via the stars. Depending on the shoot, I may also apply color labels.

It's very much worth taking a number of passes; I find my opinions evolve over the course of reviewing the shoot—often I find out I'm really looking for something I didn't expect. So don't be too hasty in giving everything 1 star, and certainly don't start throwing things away. I would prefer to mark the rejects as such (with an X) and decide about them later on in Lightroom (and if you shot Raw, you're only deleting the JPEG anyway—marking them as Rejects lets you properly delete the Raw file as well later on).

After my close inspection in Loupe & Fullscreen views, I find it's easier to finish my ratings in Grid view, where you can select multiple images and apply Flags, Stars, etc. in batches. Toward this end, note the All/Invert/None tabs at the bottom right—these are handy shortcuts.

▼ I can't be the only one that finds it deeply satisfying to look over a catalog that's been neatly organized according to a variety of criteria, can I?

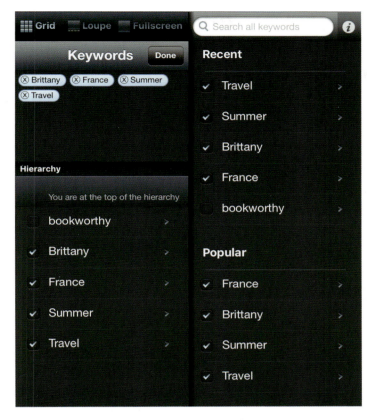

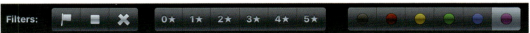

◄ I tend to start the keywording process globally, by highlighting all the images in the collection (assuming they're all from the same shoot) and inputting the broadest keywords that I know apply to all of them. Then I drill down.

One way I avoid this from being too tedious is to use the Color Labels as I'm going through my Loupe and Fullscreen passes. Broadly I'll think Purple for Landscape, Red for People, Green for Street, and so on. Then, when I'm tagging, I can tap on Set Filters, and sort only a particular color. Then, with them all selected, I'll add the relevant keyword.

You can also create Keyword Hierarchies, by tapping on the > arrow to the right of each keyword. Doing so will set that particular tag as a "parent," under which you can then create subordinate keywords.

ASSIGNING KEYWORDS

Proper keywording workflow just gets no love. Yes, it's tedious, and it's not nearly as simple and dare I say pleasurable as rating and organizing using the more intuitive other organizational tools. But it is extremely important in a professional workflow, and also incredibly helpful later on. I am certainly guilty of ignoring keywords for years, until I had an image library large enough that it became an absolute necessity for finding what I was looking for quickly and efficiently.

And if you haven't started using keywords, this is a perfect opportunity to start. Photosmith makes it as easy as it can be, and most importantly, you're stuck in an organizational app here—you can't give into temptation and start editing your favorite shot quite yet. This is the calm, methodical, and laborious phase that sets you up for a proper editing session to follow. Tap on the Tagging tab at the bottom left (next to Catalog), then tap in the Keyword box.

Syncing with Lightroom

This is where things get really neat.
So, you've got an SD card with Raw files on it. And on your iPad, either in the Photos app or in Photosmith's own sandbox, you've got JPEGs. (You may also have Raw files in the Photos app to which Photosmith is linked—it makes no difference.) You've organized, tagged, rated, added keywords and metadata the day's shoot, and now you're back at your desktop, ready to import your images into Lightroom and start the "real" (I would prefer "traditional") parts of your workflow. What you need to do is import your Raw files just as you always do, but then sync up all your work in Photosmith to those Raw files, so that you have

your head start on your Lightroom work. Note that you won't be able to rename your Raw files as you import them—they need to stay the same filename as their associated JPEGs.

Now, I promise you that once this is all set up, it's a truly amazing feature, and works seamlessly with your existing methods. But it really does take a fair amount of setting up—all very simple and straightforward though. The first thing to do is go to www.PhotosmithApp.com and download the free Lightroom plugin. Then open up Lightroom, go to File > Plugin Manager, click Add, and open up the plugin. Then...

◄ With the plugin installed in Lightroom, go to Publish Services and find the Photosmith tab, then click Set Up...

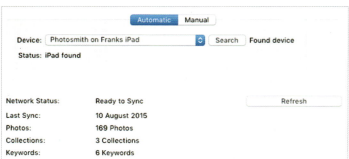

► That will bring you to the Lightroom Publishing Manager. Now, make sure your iPad is on, open to Photosmith, and connected to the same WiFi network as your desktop. Then, under the Network tab, click Search, and Lightroom should automatically find your iPad.

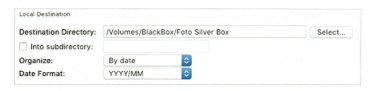

▲ Next, under the Photosmith > Lightroom Image Options tab, go to Local Destination, and input the identical destination that Lightroom uses when it imports photos normally. Also be sure to select the identical Organize and Date Format options (you can check in Lightroom Import dialog, on the right column under Destination). Then click Save.

◄ Next, in Lightroom, go to File > Plugin Manager. Scroll down to Plugin Preferences > Photo Duplication, and select "Don't download via Wi-Fi."

► Just below that, under Matching Options, select all options EXCEPT File Size. (If you have a good pre-existing reason not to select one of the other options, by all means, leave it unchecked as well; the important thing is that File Size not be checked.) Click Done. at the lower right.

◄ And finally, go to Lightroom > Preferences > General, and under Import Options, make sure to uncheck "Treat JPEG files next to Raw files as separate photos. The other options are entirely up to you—just make sure that last option remains unchecked. At this point, I would restart Lightroom, just to be sure.

▼ Now you're all set. Back on the iPad in Photosmith, import a Collection, and organize it as you see fit. When you've made all your adjustments, tap the Sync tab at the top left.

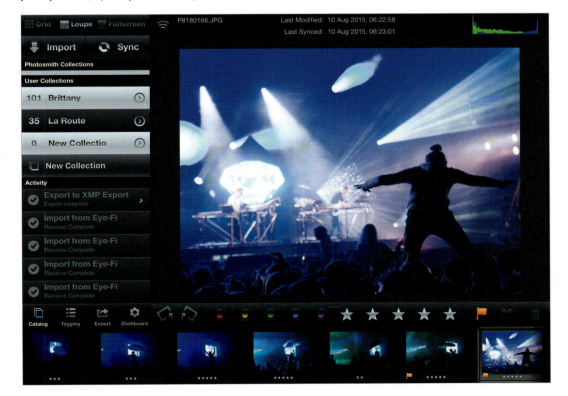

► Simply select your Collection and tap Sync collection at the top right of the pop-up window. A progress bar will start up, and in Lightroom (on your desktop), you'll see a small double-frame icon appear in the bottom right of each thumbnail indicating the Raw file has been properly paired up with its JPEG. And best of all, you'll see all the stars, labels, keywords, and everything else start popping up in your Lightroom catalog!

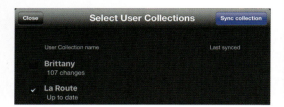

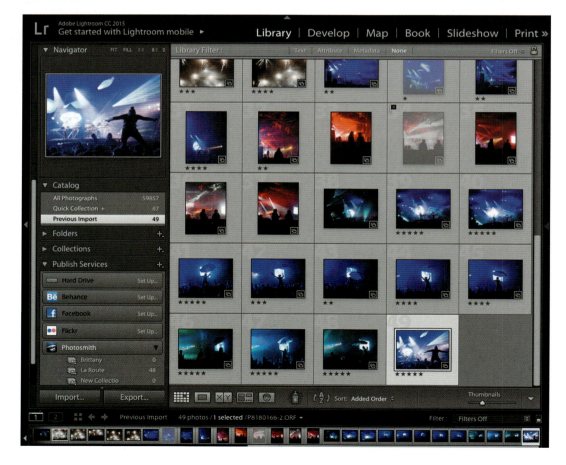

▶ Simply tap the Export tab at the bottom left (between Tagging and Dashboard), tap iPad Album, and you'll be prompted to either create a new album for your selected photos, or add to an existing one.

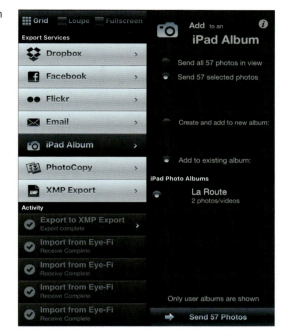

EXPORTING TO IPAD ALBUM

If you imported files directly into Photosmith, they'll be inaccessible to other apps unless you export them as an iPad Album. Of course, now you've got the image files in two places on your iPad, which was the major benefit of importing them directly into Photosmith in the first place, but maybe you're working completely wirelessly and didn't want to use the Mobi app (because, remember, it strips out the filenames and applies new ones, which isn't helpful for this Lightroom workflow.

EXPORTING TO DROPBOX

This is a handy option if you want to share your selects with a third party before you're back at your desk. If you plan on sharing the Photos via Dropbox anyway, you can skip the iPad album and go straight to Dropbox.

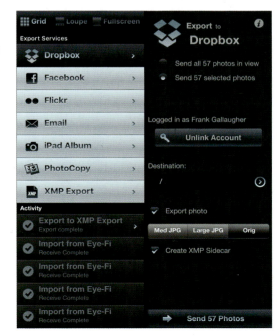

▶ As above, tap Export, then Dropbox. You'll first need to link your Dropbox account, but that's just a very simple approval process so long as you already have the Dropbox app installed on your iPad. Once that's done, you'll have the option to specify a destination folder (it's easier to create that folder in Dropbox itself first). You can also either export the original images (well, a copy of them), or downsize them to Medium or Large JPEGs, as well as adding in the XMP Sidecar data.

Editing Photos

I hope you've been waiting for this chapter—in fact I bet you've skipped ahead to it. That's all right; I agree that being able to edit photos directly on the iPad is one of its coolest features, especially now that its internal processor is up to the task.

There is a truly astounding number of image-editing apps out there, and to give a comprehensive overview of the field would more than fill up this book. Rather than superficially skim over a bunch of apps with redundant features, here I've picked just three. We'll start with, you guessed it, the Photos app, because Apple has developed it to be quite capable at performing basic adjustments, and as always, it integrates the best with the iOS ecosystem.

Then we'll dive into my favorite app, the one I use for almost every image I share directly from the iPad: Snapseed. When originally planning out this chapter, I had a number of other editing apps I expected to need to cover, but Snapseed does everything I want in an iPad editor, using the most intuitive touch interface of them all.

Finally, we'll take a look at PiRAWnha, because it's a Raw processor. Right there on your iPad. Impressive.

The Photos App used to be little more than a repository for your images, but over the years it's gained some fairly decent, if basic, editing options. If you're eager to share an image and you know exactly what basic adjustments you want to make, this is a fine place to do so, as nothing is more connected than the Photos app. There's nothing high-end, but all your usual Exposure and Color adjustments are here, along with a capable crop tool, and some automatic features.

Note: The Photos app is nondestructive, in that you can always go back to your original image after making edits. However, it isn't clear that's the case—when you tap Done after making some edits, it says "Saving" and the original image won't appear in your library. You have to go to your edited image, tap Edit again, and reverse the changes you made in order to revert back to your original photo.

♡ ⬆ 🗑 **Edit**

◄ Start by pulling up a fullscreen view of the photo you want to work on, and tap Edit up at the top-right corner of the screen.

▼ This is the basic Edit screen, with your toolbar down along the bottom. From left to right, the tools are AutoEnhance, Crop (and rotate), Filters, Adjustments, and More. Let's start with AutoEnhance.

▼ A simple tap on the magic-wand icon will make a series of automatic adjustments based on what iOS thinks is needed to improve the image. It almost always involves a slight saturation and contrast boost. It's a start, but it's nothing special.

► But in the spirit of exploring the automatic adjustments, let's skip ahead to the Filters icon. Tapping here will pull up a range of nine preset filters that can be applied to your image. They cover the popular Instagram-like styles, including cross-processing and polariod (Instant). I often find myself checking how the filters look in their preview thumbnails, as it's a very quick way to visualize the editing potential of your image. Sometimes it wouldn't occur to me that the shot would work in B&W until I see it here.

Mono

Tonal

Noir

Fade

Chrome

Process

Transfer

Instant

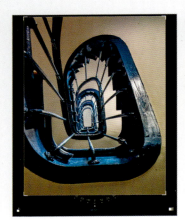

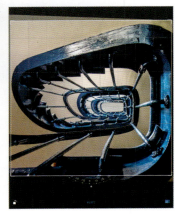

▲ Let's have a quick look at the crop/ rotate tool. I've loaded in a strongly graphic shot, but it needs tightening up. First I just tap the rotate icon to turn it.

▲ Now, since the output is destined for Instagram, I'll tap at the bottom right to pull up a list of aspect-ratio presets and select Square.

▲ And while setting the crop, I can also fine tune the rotation by using the degrees slider that pops up at the bottom of the image.

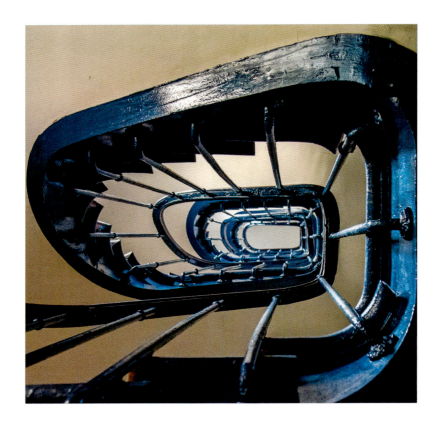

► And there we go! Just a couple processing steps bring a snapshot up to a strong image with lots of geometric pull.

► Now let's take a look at the color and exposure controls that Photos offers. This shot of Koh Pha Ngan in Thailand has loads of potential with all its color, it just needs some help getting there. The first step is a simple one—just tap the Adjustments icon, then Color, and then tap on the List icon that pops up next to the range of auto-generated thumbnails. (Those thumbnails offer a range of automatic adjustments, and makes them very easy to visualize; but you don't get the degree of fine control that the List icon offers.) Here I'm just boosting the global saturation a tad (it doesn't need too much).

◄ Next I'll switch to the Contrast option of the Color tool. Note that this is not an exposure adjustment—it's more akin to the Vibrancy slider in Lightroom, in that it continues to add saturation, but leaves already-saturated tones alone. Here, I've pulled it up just enough to pull the sky to a darker, bolder tone, but the tones in the beach huts haven't changed much at all.

► The last option here is Cast, which is sort of like adjusting the color temperature. I'm actually glad they called it this, because you're only ever working in JPEGs here, and that means you can't actually adjust the white balance—you can only add a color cast to mimic the effect. Here, I want to warm it up a touch to give that beach feeling, so I pull the slider up until I just start seeing a yellow cast in the clouds. Be careful here though, as it's easy to get nasty posterization effects with this tool; it's best used with a very light touch.

◄ Done with Color adjustments, I've now tapped on the Light icon, then brought up the fine control under the list view. The first stop is the Black Point, which I'm thrilled Apple has put in here, as it's usually the first exposure adjustment I make. It's a pre-contrast contrast adustment, basically, and I'm setting it so there's some definite shadow areas in the darkest parts of the trees. This starts adding depth and dimensionality to the scene.

► In the Highlights adjustments, I really just want to show you that there's not much power here, because again, you're working in a JPEG, and there simply isn't a lot of detail sitting in the highlights waiting to be recovered. And if you pull it back too much, you'll get very fake-looking clouds. This is a teensy adjustment just to give some edge detail to the clouds, basically.

◄ The last step is just to boost the Brightness, to make the image pop. It's already got nice contrast from the Black Point; the harsh sunlight took care of the rest of the contrast on its own. I tend to err on the side of a brighter image than a darker one, especially for upbeat holiday/travel shots like this. I keep in mind that this is likely to be viewed on a variety of screens that don't have their own brightness settings maxed out.

▼ Here you can see how the final shot looks in a proper print, with all the editing having been done only in the Photos app.

Snapseed

Snapseed was built from the ground up as a touch-interface image editor by the software experts at Nik—also known for their Efex Pro desktop editing suite (and Google bought them out a while back, so clearly they've got something going for them). The controls are extremely intuitive and the editing effects highly refined; it's easily my favorite editing app. And it's totally free!

You can work on Raw files here, but you won't be interacting with the Raw data itself, only a high-res JPEG that's automatically generated from the file. Short of that, though, it's got some variation of almost all the most commonly used editing tools from Photoshop and Lightroom. It's also got a wide range of filters, as detailed on pages 74–75. Snapseed is sort of a hybrid like that: If you want to do some serious, refined editing work, its tools are more than adequate; if you prefer to slap a popular filter look on your shot and post it straight to Instagram and Facebook, it's as good at that as any other as well. Better, in fact, because even in its filter effects, it offers a degree of control that most apps don't.

This app is really worth exploring in depth, so I'm going to walk through all the adjustment tools with one exhaustive example, and then dabble in the filter effects to show what's possible.

▼ Launch Snapseed and tap Open at the top left. You'll be able to choose from any photos found in your photo library. Once you select an image, you'll be given a Preview to confirm that's the shot on which you want to work.

Then you'll be presented with a grid of editing options. The first nine, shown below, are the Basic Adjustments. These give you all the fundamental manual editing options. Let's work through them on a sample image.

► I tend to skip straight to the Crop tool so I'm concentrating only on things that will end up in the final image. I'm going for a square output, and when you tap that preset, you'll get some guidelines to help line up your composition.

◄ When the image loads up, tap on the bar graph at the bottom left to turn it into a histogram, which will automatically update as adjustments are made. It's not RGB or even terribly precise, but it does help you keep track of your exposure changes.

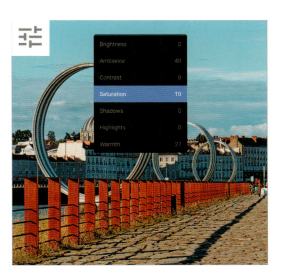

► Next is Details—two simple controls, Structure and Sharpening. The image is very sharp as it is, so I'm just going to add some Structure, which is like the Clarity slider in Lightroom.

◄ Now I'll go to Tune Image, which is the real meat and potatoes of this process. This has most of the essential exposure adjustments, plus Saturation, Warmth, and Ambiance controls. Here I'm adding some of each.

◄ In Selective, I can set a Control Point that intelligently affects a set area, allowing precise adjustment of Brights, Contrast, and Saturation. My goal here is to put an accent on the dome contained in the circle, so I'll set the Control Point right in the center, and pull up the Contrast and Saturation.

▲ Brush is a local-area adjustment. Here, I'm painting over the fence and grass, and adding some saturation that will create a strong color contrast with the sky above.

▲ Then in Spot Repair, I'm just going to tap a few times to clean up some of the straggling clouds in the sky. It will automatically sample nearby areas for the fill.

▲ Finally, I'm going to add a teensy vignette—just enough to darken the sky a bit and add a polarized look. It's subtle enough that you probably won't notice it (but your brain will).

▲ Now that I'm all done, I want to point out a fantastic feature—tap on the number at the top right of the screen and you'll pull up a History menu showing every stage of your edits. You can tap on any one to review what the photo looked like at that stage, or even revert back to that step of the processing. I love this feature; it's quite high end for a mobile app!

◄ And here's the final shot.

▲ Before leaving the Basic Adjustments, I want to point out one very cool one: Transform. This is a perspective-correction tool, ideal for fixing the keystone effect in wide-angle shots of tall buildings at close range, like this above.

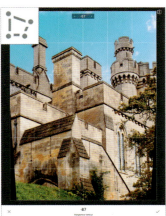

▲ Simply slide up or down to select Vertical or Horizontal correction, then left to right to make the adjustment. For keystoning, you want a negative Vertical adjustment value. Doing so will crop the bottom corners of your image, but...

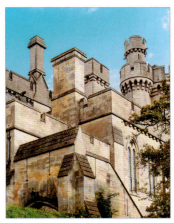

▲ ...Fortunately, Snapseed features Content-aware Fill! It will automatically fill in the cropped corners with samples from nearby areas. It's not perfect, but it usually does the job, and saves you from cropping off the sides of your shot.

CREATIVE ENHANCEMENTS

That's what Nik/Google call them anyway. These are filters, and will be familiar from Instagram, PhotoFX, and a few thousand other apps. If I sound less enthused than on previous pages, it's because a lot of these are gimmicky. That's not to say they're not fun, but I strongly advise that you err on the side of caution (i.e., usually the left side of the slider) and not get carried away. That said, if I'm ever going to apply filters, this is where I'll do it, because all of these operate using Snapseed's intuitive touch interface, of which you by now know I'm a fan.

Rather than spend a few dozen pages delving deep into all the options here, I'm just going to give straightforward descriptions of each filter, and encourage you to explore these yourself. Some are great (Black & White), some are not (HDR Scape), but in the end it's a matter of taste.

Lens Blur

▲ This used to be called Tilt-shift, and it's exactly that: an emulation of the tilt and shift effects of large-format movements. You can switch between a linear and circular effect, and control the shape of the latter to a great degree. You can be heavy handed and do the miniaturization effect, but that's pretty played out; I prefer a light touch just to pull focus to a subject.

Glamour Glow

▲ This filter can be gorgeous for portraits, with a light touch. It's mimicking the old-fashioned soft-focus portrait look, basically by decreasing mid-tone contrast. Sometimes it works very well on nature subjects as well—something to keep in mind. You can also adjust vibrancy and warmth from within the filter.

Tonal Contrast

▲ I use this all the time. It allows you to adjust contrast in specifically only the highlights, mid-tones, or shadows. You can also protects shadows and highlights from getting clipped. It's a huge degree of control that works wonders for detailed subjects with a wide dynamic range. You can acheive a similar look in the Details > Structure tool, but this is much more refined.

HDR Scape

▲ Do me a favor? Please skip this filter. I'm sure Snapseed had to include it as HDR is such a household name, but you are in no way getting HDR shots out of this. It's just overcranked mid-tone contrast and nauseating amounts of saturation. Don't. You'll thank me.

Drama

▲ Some subjects deserve over-the-top contrast and detail, and this is the filter for them. Straightforward options: besides saturation, you have six style presets, and the ability to adjust the strength of each. This is a highly stylized filter that works well on landscapes with dramatic lighting, and even some types of street photography. Not for portraits though!

Grunge

▲ There are 1500 style presets here. I'm not kidding. You can really get lost in this one, but honestly it's kind of fun, if for no other reason than it will give you some interpretations you would never have thought of otherwise. Snapseed knows they went overboard here because they even give you a Shuffle option to randomly select styles. Play around, it may surprise you.

Grainy Film

▲ This is a color-film emulator, with a wide range of film types (Styles) to choose from first, then a fine control over the amount of grain and the strength of the filter. If you keep the Style Strength slider at zero, you're just adding grain, which comes in very handy when you need to add texture to a scene.

Noir

▲ I think of this as a combination of the Drama filter with the Black & White one. The effect is inevitably brooding and cinematic, and works really well with cityscapes, particularly if there's harsh light. A cool feature is the Wash slider, which effectively clips highlights and shadows to simulate over-processing.

Black & White

▲ This is fantastic for B&W conversions. Nik has made a name for itself with its Silver Efex Pro B&W software, and it shows here. Adjustments include Brightness, Contrast, and Grain. In addition, there are six Presets and five Color Filters. Honestly, for rendering B&W, I prefer this interface to even Photoshop and Lightroom

Frames

▲ Pretty straightforward: you've got 23 different frames to choose from, and by clicking on Options you can also use this filter to crop to square. The filters range from subtle to gimmicky, and obviously I'm more of a fan of the former. Plenty of images deserve the finishing touch of a frame—just consider what sort of display it's likely to be viewed on.

Vintage

▲ If you're looking for a nostalgic look, this is definitely it. Besides your basic Brightness and Saturation adjustments, you also have nine styles and four textures from which to choose, and you can independently set the strength of each. Plus with the Center Size slider, you can apply the filters as a vignette.

Black & White

▲ Here's your lo-fi lomography filter, complete with Light Leaks, Scratches, and an elaborate array of styles that can be fine-tuned in a number of ways. In my head this overlaps with the Grunge filter above—the effects are extremely unpredictable but it's a lot of fun to play around and see what you can come up with.

► Here I'm just going to walk you through a typical edit workflow. So, to start, I've got a decent street shot. Iconic bridge, some people giving life, and a passing train that imparts a sense of moment that pulls it all together. But it was an overcast day and the lighting is bland, so...

▲ ▼ My first stop is Black & White. Of the presets, Contrast is the best fit. I'll also apply a green filter to pull out some detail in the various crevices of the bridge's masonry and ironwork.

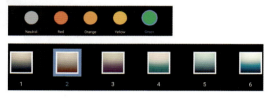

▲ But B&W alone isn't quite capturing the Paris Belle Époque atmosphere, so I'll drop into Vintage and add a color style.

Brightness	0
Saturation	0
Style Strength	21
Vignette Strength	30

▲ Now it's really coming to life. But it's not quite moody enough, so while I'm here in Vintage, I'll add a vignette, which I can fine tune via a control point, and then boost Inner Brightness while pulling back the Outer Darkness to push focus away from the corners and into the image. At this point I'm happy, but I think it could use a frame—just some curved edges.

▲ And voila voila! Paris' Pont de Bir-Hakeim in all its fin-de-siècle glory! This is why I implore you to play around with these filters, because going too far overboard on any one in particular gives trite results, but if you use each subtly enough, they can combine to create something quite original.

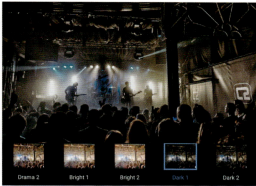

▲ Now I want to show off one last amazing feature: the Stacks brush, which functions like a History brush in Photoshop.

▲ I want to give this concert a Drama filter, but I don't want to lose the vivid color of the stage lights. So I apply the filter, then...

◄ I tap on the number at the top right of the screen, then tap the Drama tab, which pulls out these three options. Tapping on the Brush icon will revert the image back to its original, but you'll be able to brush on the Drama filter's effects.

► You can adjust the size of the brush by zooming in and out, which is how I got fine control over the beams of light. Then I tapped Invert to reverse the mask, and then zoomed in to touch up the heads of the audience at the front near the stage. Then I tapped done, and...

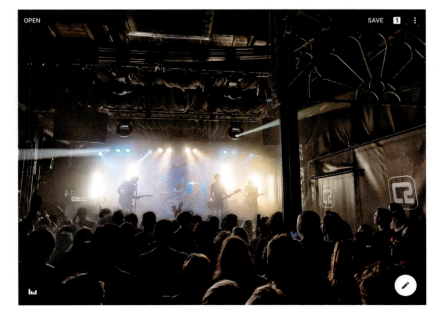

◄ The Drama filter's effects are applied to only the crowd, and the stage keeps its brilliant and vivid colors! This is just one example of the way you can selectively apply filters—and, as befits the name of the Stacks Brush, you can stack this effect with as many adjustments and filters as you like!

piRAWnha

PiRAWnha is the real deal: a fully fledged Raw converter, right there on your iPad. No proxy JPEG editing, no syncing with Lightroom; you can import a Raw file to your iPad, convert it, and save it back to your camera roll. Let me warn you now: it's pretty slow, and taxes even the latest generation of processors. It helps to close down other apps running in the background. I'll start by walking you through the controls along the menu panel, then we can work through a sample image.

Load Photo: PiRawnha automatically recognizes your album names at import.

Exposure: A global adjustment—positive values will shift the entire histogram to the right; negative will shift to the left. Use this only if the image is obviously over- or underexposed.

Gamma: This affects only the shadows—values greater than 1.0 will pull up the shadows, making them brighter; lesser than 1.0 and pushes them down and darker.

Brightness: Similar to the Exposure slider, but this mostly effects the mid-tones rather than all tones globally.

Contrast & Mid-Level: This is different than your normal Contrast control, insofar as it automatically protects highlights and deep shadows from clipping (but it does let them get very very close to clipping, which isn't terribly different). It also works in tandem with the Mid-Level slider: Contrast controls global contrast, and Mid-Level determines where the mid-tones fall. If no Contrast is applied, the Mid-Level slider will have no effect.

White Balance: This feature alone may be worth the entire app, as only a real Raw converter allows you to set the White Balance. It's rudimentary, insofar as there are no presets to guide you, only a slider to manually specify the color temperature and tint values. But with some trial and error it get the job done.

Curves & Levels: These are as straightforward as you'll find in any other editing platform. Curves is an incredibly useful tool, especially when you're working with the amount of data present in a Raw file (I find that pushing around JPEG tones in Curves very quickly renders unnatural results). Levels doesn't actually show the levels, but rather just the Black and White Points (and a further Gamma adjustment that's best left alone). It's often handy to pull up the Black Point just a few degrees if your shadows appear a bit too murky and the image lacks depth.

Hue, Saturation, & Shadow: Again, pretty straightforward. Hue shifts the colors globally, and is handy for getting rid of a color cast that the White Balance control couldn't fix. Saturated is a smart tool that boosts only muted hues, keeping already-saturated hues (like skin tones) from going over the top.

EXIF data: This is surprisingly difficult information to find on the iPad! Here a pop-up menu displays the Filename, Camera, Time, Dimensions, File Size, Exposure information, Focal Length, and Flash status.

Toggle: Here you can swap between Current, Previous, and Original views. It can be used as an Undo command, or a before-after preview, as you can swap back to the Current view from either of the other views.

Presets: Once you've made all your other adjustments, you can click Save to store them as a preset. Then when you load the next image, just open this menu again and click Apply to use the same adjustments.

Help: This will open up a lengthy instruction manual to all the various options of the app. If you have any question not answered on these pages, you can try perusing this document.

Crop: A basic cropping tool with presets for various aspect ratios: original, 3:2, 4:3, 16:9, or 1:1.

Rotate: Couldn't be simpler.

Blur: This is simply a reverse Sharpen filter, which has a side effect of obscuring harsh noise patterns.

Sharp: Raw photos almost always need some degree of sharpening before output, and here there are a number of simple presets that get the job done quite well. I usually tap the Web preset and I'm done.

As you can see, piRAWnha offers plenty of options, but truth be told, it's not nearly as slick an interface as, say, Snapseed. The major benefit of piRAWnha in a mobile workflow is to pull back blown highlights, because as a Raw processor, it's able to access that sweet, sweet detail that's hidden in the highlights. Here's a quick example:

◄ This cathedral interior shot has clearly blown highlights in the stained glass, but I know for a fact there's plenty of structure and color hidden in those windows. With the image loaded into piRAWnha, you'll notice there's no Recovery tool as such, so I have to make do with what's on offer.

► I can pull the Brightness slider way, way down, and would you look at that! Plenty of detail in those windows; of course now the rest of the shot is hideously dark, and those shadows need to be pulled back up to match.

▼ I find the Shadow adjustment in piRAWnha very finicky—it can give color casts very easily (though that seems to depends on the camera manufacturer's type of Raw files you're working with, so maybe you'll have better luck). In this case, I brought the shadows up as much as I could before the cast started becoming too apparent. Then I exported the shot and finished my adjustments in Snapseed. That's a typical step in my mobile workflow, moving an image between apps. Knowing the strengths and weaknesses of each particular app will guide you through them as you develop your photo. Once you're used to the workflow, it's not much different than moving around in Photoshop or Lightroom's development modules. And the end result is plenty detailed in both the shadows and the highlights.

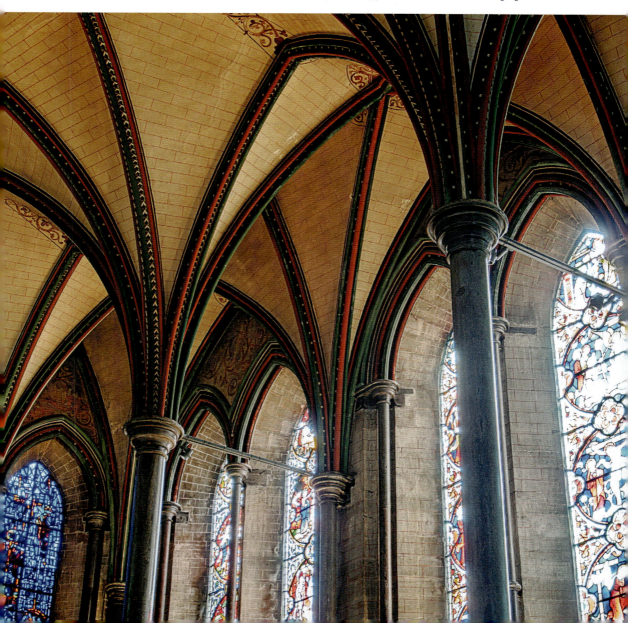

Lightroom Mobile

Lightroom has established itself as the premier image-management and Raw processing software of digital photographers today. It's what made me fall in love with editing (not to be too dramatic). If you've never tried it, I highly recommend downloading a free and fully functional 30-day trial, just to see what you're missing.

It took Adobe a long time to release Lightroom Mobile, and clearly it's taken a lot of work to get here. What we have now is a window directly into our complete image library, one which we can take with us wherever we go, editing photos as we see fit, and seeing those edits appear magically back on our desktop. Except it's not magic, it's just cloud syncing, and once you understand what Adobe is doing and how they're doing it, you'll have an easier time organizing your files, and a more enjoyable time working on them.

Lightroom Workflow

There are three components here:

Lightroom (i.e., your desktop app, directly connected to all your high-res images), Lightroom Mobile (the app on your iPad), and Creative Cloud (Adobe's cloud service, which has a number of other features, but we'll be concentrating on how it's used in making the Mobile app work for now). Creative Cloud is always the link between the two versions of Lightroom; even if your iPad is sitting inches away from your desktop, even if it's plugged into your desktop, your photos are being uploaded to the internet and downloaded again each and every time a transfer is made. Silly? Yes. But, well, I'm sure Adobe has their reasons.

THE WORKFLOW

Think of Lightroom Mobile (or Lr Mobile for short) as a window to your desktop, rather than a standalone processor. This workflow still begins with an old-fashioned import to your Lightroom. But it grants you the freedom to review, edit, and share huge batches of images away from your desk—and by away, I mean anything from thousands of miles away while you're flying on a plane, to a few dozen feet away while you're reclining on the sofa. To me, working in Lightroom is a joy, and the more time I spend working on and sorting through my images, the better, and that's what Lr Mobile allows.

▲ Start by opening up Lightroom on your desktop, and tapping on your Identity Plate—this is the area at the top-left corner, next to the Lr logo. You'll be prompted to Sign In using your Adobe ID. (You should also sign in to the app on your iPad.)

▲ Once you're signed in, scroll down to the Collections panel on the left column, underneath the Navigator window. You'll have a new From Lr Mobile set there—right click on it...

▲ ...and click Create Collection. You can also create a Smart Collection based on metadata criteria, or a Collection Set in which to organize multiple Collections.

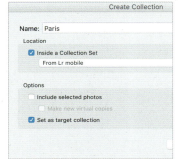

◄ Then you'll be presented with the pop-up Create Collection dialog. Enter a name for the batch of images first, and make it distinct from your other collections, as this will basically be the album name when working in Lightroom Mobile. I tend to use geographic placenames. Your new Collection needs to be inside the From Lr mobile Collection Set, so keep that box checked.

By checking Set as target collection, you'll be able to go back to your catalog and add images by selecting them and pressing B. But if you already have your images selected, check Include selected photos, and they'll be added automatically.

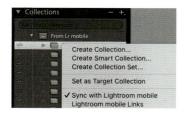

▲ Once your Collection is created, you'll need to go back to the Collections panel, right click on the new Collection, and check Sync with Lightroom mobile. You'll also see the Lightroom mobile Links option, in which you can share this collection online—this is discussed later on page 131.

How Smart Previews Work:

Smart Previews are a file type that Adobe uses in a few clever ways. They're simply a lossy DNG file—some data is thrown out in the conversion, and DNG is Adobe's own (open-source) Raw format. Smart Previews can be generated at any time by going to Library > Previews > Build Smart Previews; you can also build them automatically for each import by checking the top box in the Import File Handling dialog. Because they're DNG files, they preserve more data than a standard JPEG, and because they're lossy (and restricted to 2540 pixels on the long side), they take up much less space. The idea is that you can edit your images without being directly connected to your hard drive that contains all your original high-res files.

► Now, as you add images to your new Collection, Lightroom will automatically create Smart Previews of them and upload those to Creative Cloud. (Obviously, if you already generated Smart Previews, this process is quicker.)

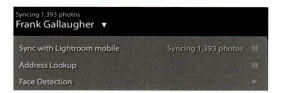

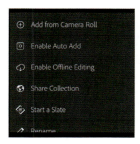

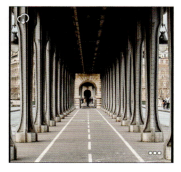

◄ By default, Lr Mobile will download only low-resolution JPEGs of each image initially; these will be displayed in the gallery view. Only once you open an image to fullscreen will the full Smart Preview be downloaded—and of course, this requires an internet connection. However, you can download the Smart Previews for your entire collection by tapping the ... icon at the bottom right of your Collection, and selecting Enable Offline Editing.

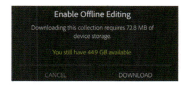

▲ A pop-up dialog box will explain how much space the Smart Previews will take up, and how much storage you have left on your device. If you have room, tap Download to start downloading. A progress bar will appear in your Collection showing the sync is active.

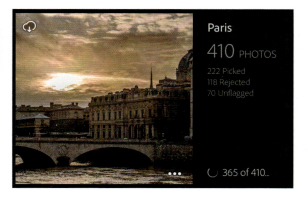

Viewing Your Collections

Half the fun of Lr Mobile is swiping through your photos on the iPad's beautiful screen. At a glance, there are three levels of viewing: the opening Collections screen, where you can choose which Collection to view; the Grid view, where you can easily scroll through hundreds of photos at a time; and the Loupe view, where you can closely evaluate each image, and then launch into editing. There are a number of ways you can set this experience up, which I'll detail here. Don't be overwhelmed by all the options—navigating this space becomes second nature very quickly.

▶ On the main screen, you'll see a list of all your Collections, with a Cover image (which you can set manually) alongside the title of the Collection. Tapping with two fingers on the Cover image will cycle through metadata about the Collection—you can show the number of photos, the number of Picks, Rejects, and Unflagged images, the total Size on your iPad, and the time of the Last Sync.

▶ Tapping on the Collections header at the top of the screen pulls up a number options for how to Sort your various collections within this screen.

◀ Tapping the Lr icon at the upper-right corner drops down a Settings menu. If your iPad has a data plan, you can uncheck Sync Only Over WiFi to allow Lr Mobile to sync wherever you go (and yes, this eats up a lot of data). The other most important setting here is Clear Cache, which you'll want to do after you Disable Offline Editing, to free up your local storage.

▶ Tapping on the ... icon at the bottom right of a Collection Cover flips over an options menu. Most of these are self-explanatory, but it's worth pointing out the Enable Auto Add will import new photos as they are added to your iPad's All Photos album. The Share Collection option is discussed on page 131—it creates a web gallery that can be publicly accessed. Start a Slate incorporates Adobe's new Slate app, which is a nifty app for easily generating interactive, narrative websites, but it's a bit outside the scope of this book. Present starts a slideshow, which is discussed on page 89.

▲ Tapping on the Cover pulls up a Grid view of your full collection. It's intelligently sorted, with vertical and horizontals fitting together seamlessly. If you tap with two fingers, you can cycle through various EXIF displays.

Share...	⚙
Open In...	⚙
Copy To...	
Move To...	
Remove...	
Set as Cover	
Present from Here	

Paris ⌄

Flat	Segmented

88	Show All	1
▭	Unflagged	1
⚑	Picked	0
⊠	Rejected	0
♡	Likes	0
▢	Comments	0
≥	☆ ☆ ☆ ☆ ☆	1
🕒	Sort by Capture Time	▲

Paris ⌄

🕒	Capture Time
📅	Modified Date
Az	File Name
▦	Custom Order
♡	Most Liked

▲ In Grid view, tap and hold on an image to pull up this menu. Here you can Share the image to the usual outlets, Open in another app, Copy or Move to another Collection, Set as Cover, or start a slideshow. This is also how you can Remove a photo from the Collection.

▲ Tapping the Title at the top of the screen drops down a menu in which you can choose which images you view (by Flags, Likes, Comments, or Stars), and also how you want the images sorted (by Capture Time, Modified Date, File Name, Custom Order, or Most Liked). You can

also tap Segmented to bring up a different view, which is reminiscent of the Collections view in the Photos app, insofar as it organizes batches of images by the month of their Capture Time.

Loupe view is where you can get down to business and really start working on your files. It serves two purposes: assigning metadata (Ratings and Flags) and editing. Both of these depend on being able to carefully evaluate each image. Toward that end, at any point in Loupe view, you can double tap to zoom to a 100% view, and scroll through the image with a critical eye. Additionally, once you start applying adjustments (or even if you've imported already-adjusted images), tapping and holding three fingers down will revert the image to its original state. I find this incredibly useful, as after a while it's easy to forget what you started from once you're in the middle of a complicated edit.

▲ In the top-left corner, there's a tiny little cloud icon that's easy to miss, but which is important to keep an eye on. It tells you the status of the sync between your current collection and Creative Cloud. If it's solid, then you're all synced up; if it has a plus sign, you're not. In fact, no changes you make in Loupe view will sync up with the cloud until you switch back to Grid view. However, you can override this by tapping on the cloud icon and then tapping Force Sync.

▲ By default, you'll see these four icons in a menu bar along the bottom of Loupe view. This is where you'll enter the Editing options—Crop, Presets, or Adjust.

▲ But if you swipe left within the bottom menu, you'll pull over a second menu in which you can assign a tag or a Star rating.

▲ It helps to rotate your iPad to the orientation of the image, to maximize screen real estate. By tapping on the image with two fingers, you'll pull up either an RGB histogram at the top right, the EXIF data at the top left, or both. Additionally, you can tap directly on the EXIF data to cycle through what information is displayed (Capture Time, Exposure Info, Resolution, Flags, Ratings, Copyright, Focal Length, Lens, or Camera).

▲ Tapping the Filmstrip icon pulls up a linear strip of images from your collection, allowing you to navigate through large numbers of images easily while staying within Loupe view.

◄ Tapping and holding on the image in Loupe view pulls up this menu on the left. In addition to setting the Collection's cover, you can also choose whether you want to be able to assign Flags, Stars, or both. When you choose both (Speed Review Combined), you need to hold the iPad with two hands. Swiping up or down with your left hand assigns the flag, and swiping up or down with your right hand assigns the star rating. Personally, I find this a bit too much—when I'm assigning these, I tend to want to get comfortable rather than bracing the iPad in both hands, but it depends on what you want to get done.

► At any point you can begin a slideshow, or what Adobe calls a Presentation. From the opening Collections view, just tap the ... icon to pull up the menu at the far left; in Grid and Loupe view, tap the Share icon at the top-right corner. Note that if you have an AirPlay device, you can turn it on by swiping up to enter the control panel.

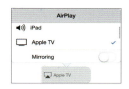

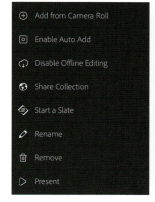

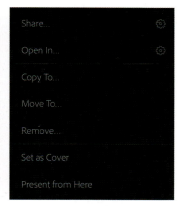

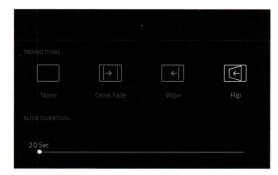

◄ Once you're in Presentation mode, tapping the ... icon at the top-right corner, just next to the Play button, will pull up a simple playback menu, in which you can choose the method of transition between slides, and the duration that each slide will be played for. It's very straightforward (no music track or anything fancy), but there are a number of times when you might want to sit your iPad down (or play it on your AirPlay device) and show off your work. I find it's best to assign some metadata and then Sort your collection by that first, so you're presenting only your keepers.

Presets

Lr

The Presets panel is the fastest way to apply global edits, and a nice, quick method of exploring the potential of each shot. Best of all (and unlike Lightroom proper), you can view a small thumbnail showing your image with each Preset applied, to get an idea of the effect with just a glance. Here's a tip: If the pop-up Preset panel is covering up an important part of your photo, just slide it out of the way with one finger.

It's important to remember that there's nothing magical about these Presets—they're all making adjustments that you can manually apply yourself in the Adjust panel. Toward that end, I'll give the "recipe" for each Preset below, because I think it's important to know exactly what's going on under the hood when working on your photos.

CREATIVE

8

COLOR

9

B&W

11

▲ The Creative presets are genuinely interesting, and each one makes a number of adjustments to a variety of different settings—too many to detail the recipe for each effect here. I particularly like the Cross Processing presets, since these are the only cross-processing options you'll have in Lightroom Mobile.

▲ Punch 1 sets Contrast and Vibrance at +25; Punch 2 sets Clarity and Vibrance at +30; and Punch 3 sets Clarity at +40 and Saturation at +35. Low Contrast means -50, and High Contrast means +100. Cool and Warm both Split Tone the Shadows with a Saturation of 50: Cool sets the Hue at 212; Warm sets the Hue at 34. Devibe decreases Vibrance to -35. Dynamic sets Contrast to +35, Highlights to -85, Shadows at +50, and Vibrance at +33.

▲ Auto B&W has the exact same effect as tapping the B&W tab in the Adjust panel. The Contrast presets build on this, by Auto converting to B&W, then adding their respective amounts of global contrast, with Contrast Low setting a -60 amount. Portrait B&W and the Film presets skip the Auto conversion and apply set values for each color channel—if you switch to the B&W panel, you'll see all the values already input there.

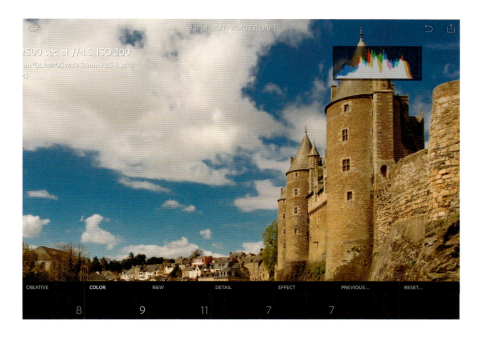

2500 sec at f/4.5, ISO 200
m (OLYMPUS M12-50mm F3.5-6.3)

CREATIVE	COLOR	B&W	DETAIL	EFFECT	PREVIOUS...	RESET...
8	9	11	7	7		

Clarity (Low)

Clarity (Med)

Clarity (High)

Noise Reduction 1 (Low)

Noise Reduction 2 (Med)

Noise Reduction 3 (High)

Detailed

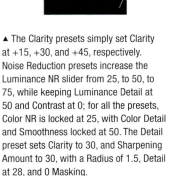

DETAIL

7

Vignette (Light)

Vignette (Medium)

Vignette (Heavy)

Grain (Light)

Grain (Medium)

Grain (Heavy)

Blur Vignette

EFFECT

7

▲ After reviewing all presets (all 42 of them!) and observing their effects, it was clear I wanted to add some Clarity and Contrast, while boosting Saturation. Unfortunately, you can't combine multiple presets—they only work one at a time. But because I understand what each one is doing, it was simple to go into the Adjust panel and combine the effects myself. That said, if you want to combine these effects, you can create a Custom Preset, as discussed on pages 96–97.

▲ The Clarity presets simply set Clarity at +15, +30, and +45, respectively. Noise Reduction presets increase the Luminance NR slider from 25, to 50, to 75, while keeping Luminance Detail at 50 and Contrast at 0; for all the presets, Color NR is locked at 25, with Color Detail and Smoothness locked at 50. The Detail preset sets Clarity to 30, and Sharpening Amount to 30, with a Radius of 1.5, Detail at 28, and 0 Masking.

▲ The Vignette presets all set a Highlight Priority Style set to -10, -20, or -30, depending on the strength. The Grain presets steadily increase the Amount and Size of the Grain, though Roughness is set much higher for Light than Medium or Heavy. The Blur Vignette centers a Radial Filter with -100 Clarity and -100 Sharpness approaching the edges.

Making Adjustments

Now let's take a look at the Adjust panel. Adobe has been steadily fleshing this out with more and more features, but in a way that keeps them relatively organized. You'll see that by default the Basic Adjustments panel is brought up, with a range of options stretching horizontally across the screen. If you swipe the menu to the far left, you can tap on the Aperture icon and pull up an additional three menus—Tone Curve, Vignetting, and Color/B&W. I think the best way to explain these adjustments is to see how they work on real images, so let's take a look at a few sample editing workflow.

◄ As usual, I'll start with a crop. Tapping the Crop icon in the toolbar pull up a very familiar interface (the degree counter looks just like it does in the Photos app). Here you can Rotate, Flip, Straighten (which has a handy Auto function), and set the crop using a preset, while keeping the Aspect Ratio locked.

◄ After making my crop (by tapping the checkmark at the bottom-right corner), I tap on Adjust, then tap the first icon on the far left, which pulls up a menu. By default, you're looking at the Basic Adjustments menu; by tapping on Color / B&W, I'm brought to a dedicated Channel Mixer! When I tap B&W, it does an auto conversion, and switches the channels to their luminance values only.

▲ Now I can customize my black-and-white conversion just how I like it, and see the effects each channel adjustment has on the image in real time. That the red channel's dot happened to land on this man's nose is entirely coincidental!

► And there we go—a customized B&W conversion, done entirely in Lr Mobile!

◄ You can also use the channel mixer in color photos. I regularly use it to imitate a polarizing effect by pulling just the blue channel down.

▲ Going back to the Basic Adjustments panel, White Balance is the first tab for a good reason—it's the first thing you want to check, as it will affect many of the other settings. Usually my camera's Auto WB does a good job, but this castle night scene clearly confused the heck out of it and made it far too warm.

▲ Tapping the Selector preset pulls up a magnification loupe, but it's usually too large at full view. Zoom into the image itself, and the loupe will shrink down accordingly, allowing a precise sample.

▲ Sampling the white brick at the top of the tower rendered a very accurate WB, but accuracy isn't everything. I'd prefer a more creative WB setting to capture the twilight mood of this scene.

◄ At a glance, I saw the Fluorescent preset hit the right balance between the warm castle and the pink flowers on the tree. A simple tap to apply the preset and the photo's ready for export!

▶ Now I'm going to walk through a complete editing session for this sunset. Typically for a sunset, the foreground is quite dark, so I'm going to boost the shadows as far as I can. Now, I have no intention of leaving them this bright, I simply want to be able to see how the next step affects the foreground area.

▶ ▶ With the foreground now viewable, I'll adjust the Color Temperature. For a sunset, this almost always means warming it up, as I want all those rich tones that the Auto WB function is trying to cancel out by setting a cooler temperature. The Shade preset works just fine.

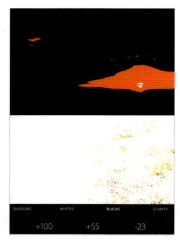

◀ ▼ Next I'll set the Black and White Points using the clipping warning. By sliding the sliders with two fingers, you'll pull up a special view that shows exactly where luminance values are dropping to 0 (clipped Blacks) and 255 (clipped Whites, respectively. Here, I'm happy for the sun itself to be plenty bright, but I'm going to stop pulling down the Blacks as soon as I start seeing clipping in the foreground—the histogram helps guide.

▶ The last exposure value I want to adjust is the Highlights. Now, as I said, I'm happy to have a bright area around the sun—it is the sun, after all. But if I pull back the highlights just right, I'll isolate some glare streaks that add a bit of drama. However, if I pull back too far, I'll hit the limits of my bit depth and get harsh banding around the sun. To make sure I get just the right amount, I'll zoom in right on the sun and keep a very close eye on it as I pull the slider down.

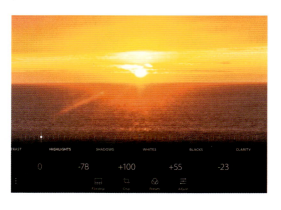

► Last step is tweaking the color. This being a sunset, and one with a warm color temperature setting, it's already looking quite vivid. I just want to pull some deeper purples out of the cloud cover, so I'll double tap to magnify again and zoom in to a view that lets me keep an eye on both the sun (which I don't want to look ridiculously overcranked) and the clouds (where I want to get as much color as I can). +40 Vibrance did the trick.

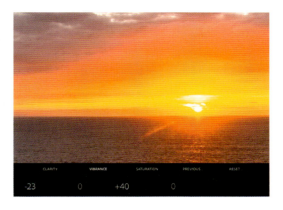

◄ Now here I'll admit that I kind of cheated. This is the finished shot, with the global exposure and color adjustments that I've gone through with you. But my very last step was adding a neutral-density gradient filter in order to brighten up the foreground without affecting the sky. But wait! There's no ND gradient filter in Lightroom Mobile! That's true, but there's a secret trick to using one that even Adobe doesn't seem to want you to know about. But fret not, all is revealed on the next page...

Custom Presets

We haven't yet talked about the Previous tab at the far right of the Adjust panel. Tapping it pops up two options: Apply Basic Tones from Previous Photo, and Apply Everything from Previous Photo. This mimics the Copy & Paste function in Lightroom, where you can make adjustments to one image, copy them, then paste them onto subsequent images. It's extremely handy if you're working on a series of similar shots, where you know the same adjustments will work across all the images. But when Lr Mobile applies the adjustments from the previous photo, it copies the entire XMP sidecar (i.e., all the adjustments, regardless of their origin). This means if you make adjustments in Lightroom that aren't available in Lr Mobile, and then load the image into the app, those adjustments will still be displayed—and you can apply those Lightroom-only adjustments to other images via the Previous Photo tab! It's a cool trick, and testament to the fact that Lr Mobile runs on the same engine as Lightroom proper, just like iOS and OSX. So here I'm going to walk you through the process of setting up your own Custom Presets. It's a clunky workaround, yes, but there's a certain satisfaction in hacking your way around Adobe's artificial limitation. And if you already have Custom Presets in Lightroom, this is the only way to apply them.

▲ Start by creating a plain black image file in Photoshop (or any other software that lets you add text). Add the name of the Custom Filter you want to create, and save it as a JPEG. I usually save them with 2540 pixels on the long side (same as Smart Previews), but at an extremely high compression rate—no sense in having these things take up space. Create as many as you like, then add them to a new Collection called Custom Presets.

▲ Now in the Lightroom Develop module, go through each of these images and apply the corresponding adjustments. They'll automatically sync across to Lr Mobile. Note that with a black frame like this, you usually won't actually be able to see the effect—that's why it's easier to just label them in Photoshop.

▲Then, when you want to apply a custom preset, just open it into Loupe view, then go back and open the image you want to adjust, tap the Previous... tab, and tap Everything from Previous Photo. And easy as that, you've applied your custom preset!

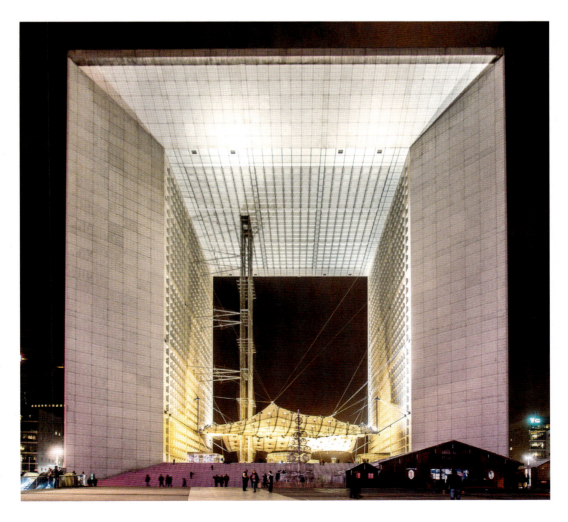

Working in iMovie

I'll admit, it took me a while to really get into working on video files. Just when I thought I was getting the hang of Raw Processing and working with Layers in Photoshop, the camera manufacturers saddled us all with HD video right there in our cameras, and we had a whole new bag of tricks to learn.

I got over it. And honestly, iMovie is how. iMovie made video editing make sense, and it gave purpose to that red Record button on the top of my camera. Now, this is not as professional a piece of video-editing software as, say, Lightroom is for still images, but it's a fantastic step into a powerfully creative world, and one I really hope you explore. And if you're coming at this from the other side, and are already fluent in more fully featured video-editing programs, I also encourage you to see what iMovie is capable of, all right there on the iPad.

Getting Started

iMovie takes a number of steps to make video editing easy, and that's apparent from the moment you open the app. The important thing to remember here is the difference between a Project and your finished movie: the Project is a proprietary Apple format that stores all your working data; the movie is what you render and export (and share) once you're finished with all your edits.

Video Formats:
iMovie may not be able to read video files from other cameras. If that's the case, I recommend using the free app HandBrake to convert your video files to the H.264 codec in an MP4 file format. iMovie will read that, no problem.

▲ When you first open up iMovie, you'll have three options running across the top of the screen. Theater is where you can review finished projects, once they're shared to either iCloud or directly to iMovie (see page 110–111).

► Tapping the Video tab will pull up all the video files found locally on your iPad, running vertically down as a list, with each video horizontally broken out into thumbnail slides.

◄ Tapping on a video will enlarge it and allow playback for closer inspection. In this view, you can also set the playback speed (via the Rabbit and Tortoise icons on the left) as well as Favorite it (via the Heart icon). Favoriting clips here makes them easier to find later on when you're adding clips to your timeline in Project view.

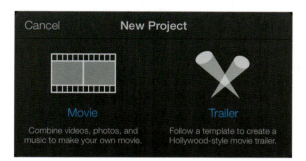

◄ To start a new project, tap the Project tab at the top of the screen, then tap the + icon at the top-right corner. You'll first be prompted to choose between a Movie and a Trailer.

► Trailer is an interesting gimmick that Apple's put together. First you pick a theme, and then fill out an Outline of a pre-scripted story with proper names for your characters, locations, etc. Once that's done, you're prompted to drop in short clips to fit into the formula of the outline. Once you've filled in all the blanks, tap the Playback button and your personal clips will be edited together in a "trailer" for a particular type of movie (I picked the Spy genre, naturally). It's fun to explore, but it's basically a game, without much creative control.

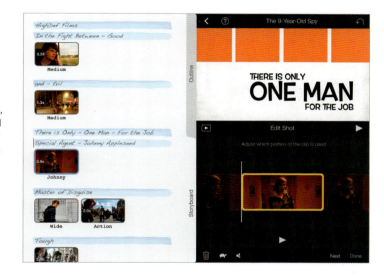

◄ Movie mode is the real deal. You'll start by selecting a Theme, just like in Trailer, but it only applies to certain transitions you can choose yourself, and you can always change the theme later on if you want (see page 109). You can tap the Playback button to get an idea of what effects are used in each Theme. Once you've made your choice, tap Create at the top-right corner.

The Editing Workspace

If you've ever worked in another video editor like Final Cut Pro X or Adobe Premiere Pro, the workspace of iMovie will look very familiar. It's a streamlined version of these professional editors, offering a similar way of working, but eschewing most of the high-end features for the sake of simplicity. But the fundamentals are all there: You assemble your clips in a timeline, connect them with transition effects, splice them together in various ways, sync up audio, and so on. The ability to use multi-touch gestures really augments the experience though. This is a highly intuitive interface that keeps you from being intimidated by all the various options you can choose from and encourages you to get down to work and start building a movie. Before we get to that though, let's take a close look at how this space is set up.

▼ There are three main components to the workspace: the Content Library, where you can select which clips to add to your project; the Timeline, where the bulk of the work is done; and the Preview Panel, where you can playback your clips at any time to see how they're all fitting together.

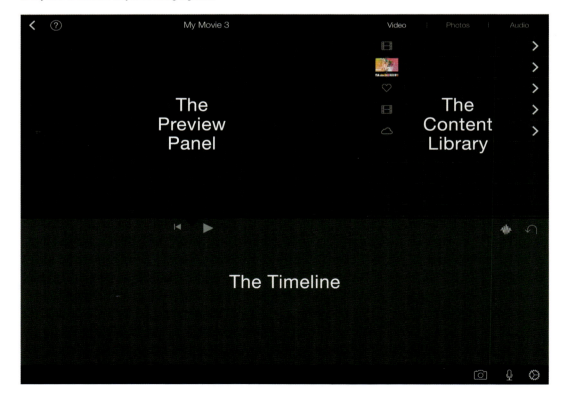

▲ Starting with the Content Library, you'll see it's organized into three tabs at the top. The Video tab will, of course, be the one you use most, and it's basically a miniaturized version of the Video tab you saw when you first opened iMovie (back on page 101).

▲ iMovie will also recognize all your still images located in the Photos app or Dropbox (but not if they were imported directly into Photosmith). If you've organized them into Albums, they'll appear here as well.

▲ And of course, a movie is nothing without proper sound, so the third tab contains all your Audio options. In addition to a stock library of Theme Music and Sound Effects, you also have full access to your iTunes library here.

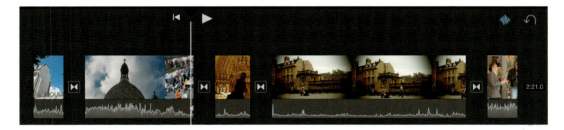

▲ Then there's the Timeline. We'll cover it in detail over the coming pages, but the first thing to note is that it you can pinch and zoom here to expand or contract the scale of the clips—you're not actually editing the duration of anything here, you're just pulling in closer so you have finer control over exactly when you place your cuts, transitions, and so on.

▶ At the top-right corner of the Timeline, you'll see two important icons. The Waveform icon displays Audio tracks, allowing you to adjust Volume. And the U-turn icon is your Undo button, and if you're anything like me, you'll be making good use of it!

The Timeline

And here's where the sausage is made,
so to speak. The Timeline is where all you'll be
doing all the work of your video editing, so it's
very important to understand how it works and
all its features.

The key is to wrap your mind around the horizontal
and vertical axes along which the Timeline operates.
Playback occurs horizontally from left to right, so
think of your separate clips as playing through a
sequence. This means that items in the Timeline
that are stacked vertically will occur at the same
time, so the Audio track runs alongside your clips
(usually), as well as certain special effects. And the
whole thing is tied together with Transitions, which
are key to making your movie look like a finished
product—clips need to flow into each other without
abrupt cuts. Of course, there are no rules to video
editing, and you may well find plenty of reasons to
have Audio tracks running on their own, or a series
of quick cuts between clips with no transitions at
all. That's all part of the creative process!

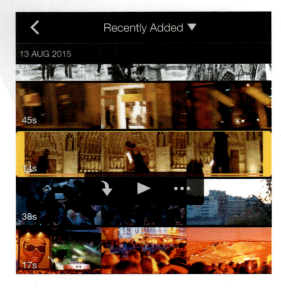

▲ Once you've selected a video in the Content Library, you can
simply double tap it to drop it into position in the Timeline. You can
also tap the Playback button to watch the clip in the Preview panel,
and drag the edges of either side to cut the clip before dropping
it in place. And if you tap the … icon on the far right, you'll pull
up four additional options.

▲ From left to right the additional options are: Audio Only (adds
only the audio from a video clip to the Timeline); Cutaway ("cuts
away" from the main clip, playing the selected video with the
main clip's audio); Picture-in-Picture (superimposes a clip in a
smaller window over the main clip); and Split-screen (both clips
play back side-by-side at the same size).

▼ The current position of your Timeline is
indicated by the vertical white line—this
is where new clips will be dropped in as
you add them.

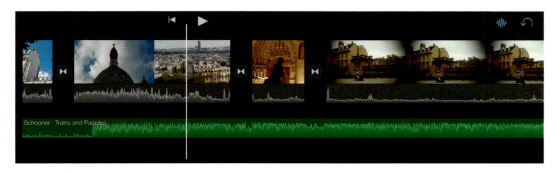

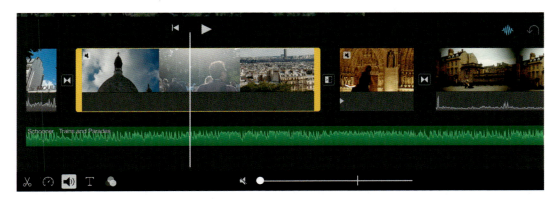

▲ Tap on any clip in the Timeline to select it (it will be highlighted in yellow), and an Edit menu pops up at the bottom of the screen. Here, I tapped on the Volume icon to pull up a slider that let me mute the video track, which I won't be needing since I've already dropped in an audio track, which I intend to play at full volume for the duration of the movie. However, I could balance video and audio tracks by turning both down and playing them back until I'm pleased with the mix.

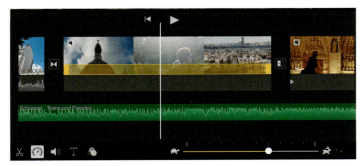

▲ Tapping the Timer icon pulls up the same Tortoise-to-Rabbit slider we saw back on page 100. Here I can speed up or slow down playback, which is particularly handy when working with clips shot at a high framerate (for a slo-mo effect).

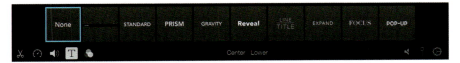

▲ The T icon lets me choose a style for Text that I can overlay on a particular clip. This is often used at the start of a movie for the Title sequence.

▲ The Filters icon (familiar from the Photos app) offers ten filters that will be applied to a particular clip (but not to the full movie.)

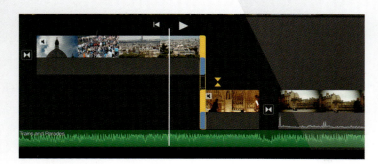

◄ Let's say I've dropped two clips into my Timeline, and now I want to add a transition between them. First, I'll go to Precision View by pinching and zooming vertically to pull the two clips onto separate rows. The yellow/blue bracket indicates the parts of the clip that will be part of the transition, and to zoom in even closer, I'll tap the inverted triangles (i.e., the Transition icon.)

► Doing so pulls up a Transition menu, where I can choose the exact duration of the transition (at the bottom left), and choose what Transition effect I want. Tapping repeatedly on Slide and Wipe lets me set the direction of those effects. The Theme transition is decided by the Theme you chose at the start of the Project (or which you changed via the Settings menu—see page 109).

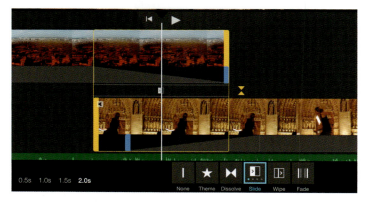

► First, I want to Trim the end of my first clip though, so I'll tap Done, then select the clip again, and tap the Scissors icon at the bottom left. Then I just pull the clip to the left.

◄ Another option is to set where I want to Trim the clip, then simply tap Split at the bottom right. This creates a new, separate clip, which I can then get rid of by tapping Delete.

▲ Rearranging clips in the Timeline is as simple as it gets: Tap and hold a clip, and it will pop out, allowing you to move it in between any other clips. It really helps to zoom out in the Timeline before doing this.

▼ And that's basically how video editing works in iMovie! You add clips from your Content Library, arrange and trim them to sync up with your Audio track, and edit the Transitions as you see fit. I tend to drop a whole bunch of clips in and work my way down, cutting and trimming first, then working on transitions.

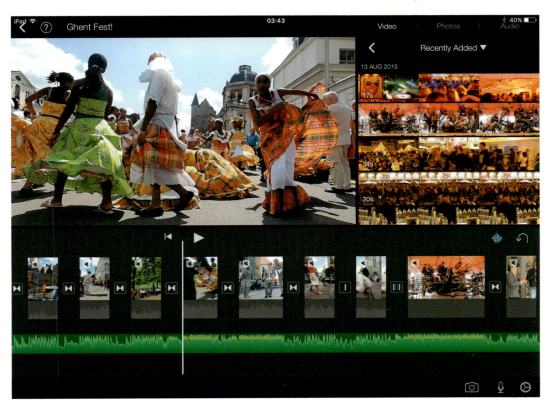

► There's also a place for still images in your iMovie timeline, especially since it features an easy-to-operate "Ken Burns Effect." This zooming-while-panning effect was popularized by filmmaker Ken Burns in his many documentaries. Start by adding a photo from your library, then select it in the timeline. A small menu will pop up at the bottom-right corner of the Preview panel. Start by pinching-and-zooming into the area of the photo at which you want the clip to start.

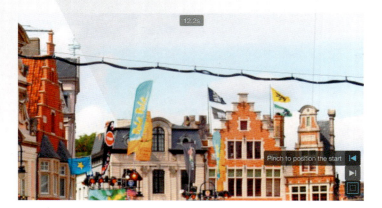

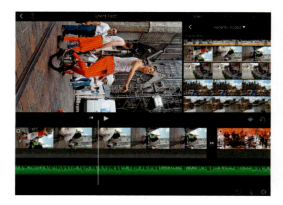

◄ Then tap the middle button in the pop-up menu, and pinch-and-zoom to the final position at which you want the clip to end. When I play this photo back as a clip in the timeline, it starts at the upper-right corner and slowly zooms out (down and to the left) to reveal the full image. And you can set the duration of the clip via the Cut tool, by simply dragging the sides in the timeline to make it longer or shorter (and there's no limit to the length).

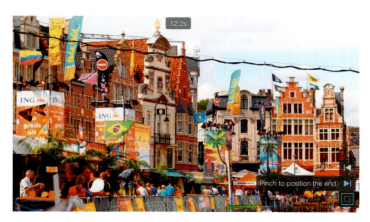

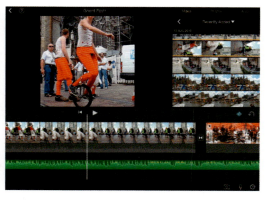

▲ We've all done it—held the camera (or phone, or iPad) vertically while capturing video. Fortunately, iMovie offers a quick and easy fix. Simply load in your vertical video, and in the Preview Panel, use two fingers and rotate in the proper direction.

▲ And there you go! The video is automatically letterboxed on the left and right of the clip. Unfortunately, it's also cropped to square, but that's better than making your poor audience strain their necks.

► Finally, at the bottom-right corner of the workspace there are three more features that we should cover. The Camera icon is pretty self-explanatory—it activates the camera so you can record video live, and the resulting clip will drop into the current position in the Timeline.

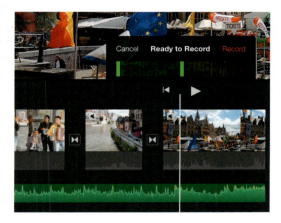

◄ The Microphone icon lets you record a voiceover directly into the Timeline. Just tap Record, and Playback will begin, automatically recording your voice on top of the Audio track. When you're done recording, you'll have the chance to Review the audio before tapping Accept to drop it into the Timeline.

► The Settings icon pulls up a number of options that apply globally to your entire Project:

Project Filter: Here you can apply a single filter effect to all your clips. There are ten filters to choose from, and they're the same ones available in the Edit menu (page 105). However, if you've applied a filter to an individual clip already, that will override this Project Filter choice.

Theme: This is where you can change your mind about the Theme you chose at the very start of the project, and is useful if you want a particular Theme's transition effect.

Theme Music: Tapping this will override any Audio tracks you've already placed with the music for the Theme chosen above.

Fade in/out: These are the intro/outro transition effects that apply to the beginning and end of the full movie.

Speed changes pitch: This applies if you've adjusted the Playback Speed in the Edit menu (page 105). If this is activated, the Audio track will slow down or speed up in sync with the clip.

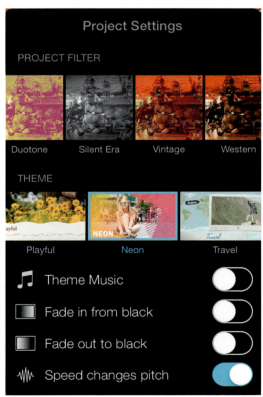

Sharing from iMovie

There's no Save button anywhere in the workspace; all your edits are automatically saved within the app, so you can exit freely and trust that your work will still be there when you return. But when you're all finished and ready to broadcast, getting your movie off the iPad and into the world is a breeze.

Exporting a file won't affect the Project itself, and you can return to edit it whenever you like. Also, the Project files themselves only link to their constituent clips (until you export a Project), so they won't eat up too much of your storage. However, you will need to keep the clips on the iPad to keep working on the Project.

▶ You also won't find the Share icon within iMovie's workspace; for that, you have to exit back to the starting screen and select your Project from there.

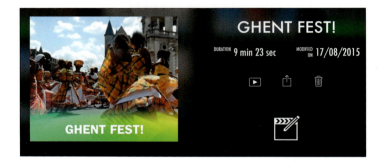

◀ Tapping on the Share icon will pull up all the usual outlets, but I strongly recommend simply tapping Save Video and exporting directly to the Photos app. It takes time to render the video file, and once it's exported to the iPad, you can easily share from the Photos app. This way you keep a copy locally, which can then be shared via other apps without having to be rendered again.

▶ You'll be prompted to select a resolution for export, and since I never want to throw away pixels, I'll always choose 1080p. It's worth pointing out that while the iPad can edit 4K video just fine (well, it is a bit slower), it can currently export only to 1080p, though I fully expect this to change once Apple hops on board the 4K train.

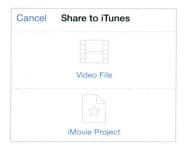

▶ Another option is to export your complete iMovie project. This exports a .imoviemobile file that contains all the constituent clips in their entirety, along with the metadata making up all your edits and audio choices.

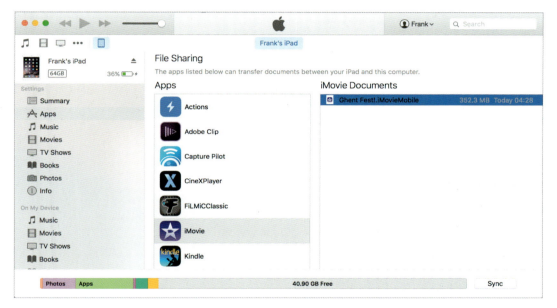

▶ To retrieve your exported project, plug your iPad into your desktop, sync it with iTunes, then go to the Apps folder and scroll down to File Sharing. Click on iMovie and you'll find your project listed under iMovie Documents. From here it's just like any other file; you can click and drag it into any folder you wish.

Compatibility Issues with iMovie
Here I have to report on what I can only imagine is a huge oversight on Apple's part. From your iPad, iMovie exports a .imoviemobile file that can be imported into other iOS versions of iMovie just fine, but which can no longer be imported into the latest version of iMovie for OSX. Bizarre, I know. You can, however, still access all the clips contained in the project, because the .imoviemobile format is just a container—simply change the extension to .zip, unzip the file, and you'll find all your clips in the Assets folder. Still, you won't be able to access your edits, so it's of limited use. I hope Apple fixes this soon!

In the Studio

The bulk of this book has been exploring what's possible with the iPad in the field, but one of the first places the iPad was used in photography was in the professional studio. The ability to hand your client, art director, or even makeup artist a high-resolution preview of exactly what the camera is seeing is both professionally impressive and a huge time-saving device.

And that's just the professional studio—there are a number of applications for your shooting and editing back at home as well. We'll take a look at the practical uses in several different situations in this chapter, ending with an overview of my favorite studio apps.

ShutterSnitch

This app has become a favorite of many studio photographers over the past few years, as it combines a wireless import process with a handy automatic review feature that helps you monitor your shooting while still concentrating on the creative factor. It's often used by an assistant helping the photographer, so that the latter can be totally involved in the shoot, while the former critically evaluates each shot as it is imported. Raw files are supported, but there's no editing happening here, and only a basic five-star rating system to work with. This app is really all about on-the-fly reviewing as quickly as possible.

▼ ShutterSnitch works with many cameras' built-in WiFi, as well as my old standby, the Eye-Fi cards. As long as the card is already set up in the proprietary app, setup is a simple matter of selecting it from this list.

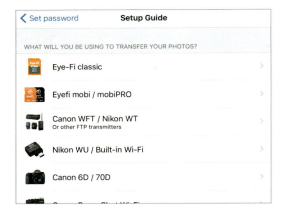

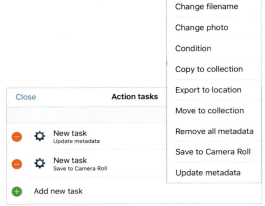

▲ The Action Tasks have to do with the import process, and will instruct the app to make any number of changes and adjustments automatically upon import. I use the Update Metadata option to add my copyright, along with the name of the shoot, if that's relevant. Change Photo will resize to a pre-specified JPEG resolution. The Collections refer to a list of pre-approved apps like Dropbox or Flickr.

► This is where things get interesting. Under Warnings, you can instruct the app to scan each incoming image and compare it's metadata against a list of rules you set. It will then display a large Warning over the image in review if any of these rules are broken.

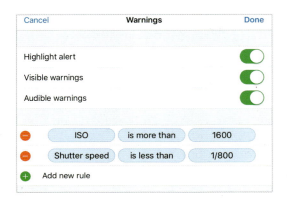

▶ The Warnings function is particularly handy for an assistant reviewing photos as they fly into the iPad. There can be any number of reasons the photographer may want to keep shutter speeds above a certain level, or ISO to a minimum (usually simply to maximize image quality). You can also set a Highlight Alert to automatically flash overblown highlights in dark red, which gives specific feedback regarding the exposure for the current scene. Note also the EXIF data running across the very top of the screen, and the filmstrip running along the bottom.

▼ Once the shoot's over and all your images are imported, you can Share via the usual outlets, and even compress and archive the photos in a .zip file along the way. But best of all is that ShutterSnitch is 100% compatible with Photosmith. Simply select PhotoCopy to app..

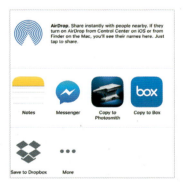

▲ ...and choose Copy to Photosmith! The photos will automatically be imported there, so you can begin your Rating & Tagging process (detailed on pages 50–57).

WiFi Tethering

Seeing a live display of your shot as you compose it on the iPad is quite exciting the first time you set up WiFi tethering. It's one of those moments you realize how cutting edge digital photography is at the moment. But to be honest, it's most useful in only rather particular situations—studio shots being one of them.

After you play around with the features for a while, you're likely to realise that just holding the camera in your hands gives you significantly more control over your shot. But in studio shooting it's genuinely useful, so you should absolutely explore the WiFi capabilities of your camera (if it is WiFi-enabled, of course).

▶ You'll start by navigating in the camera's menu to the WiFi control setting. Sony does things a bit differently (of course), in that it actually hosts a number of apps on the camera itself. But the Smart Remote Control app works just like the WiFi control function of other cameras.

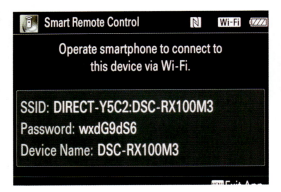

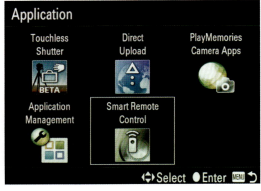

◀ The next step is connecting the devices—this is rather like connecting to an Eye-Fi card as discussed on pages 32–35. Some cameras use a password to manually connect, while others use a QR code to automatically sync the two devices.

▶ After the first time the two devices are connected, it's a simpler matter on subsequent uses. For Sony's app, I've prioritized its ad-hoc WiFi signal so that as soon as it broadcasts, the iPad switches to it.

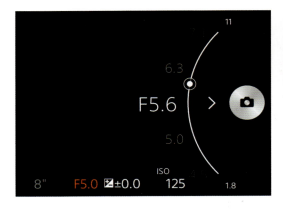

◀ Sony's app has a very sparse interface, but it covers all the major exposure and focus controls (I've taken a pure-black shot just to make them more visible here). Other cameras may allow only automatic modes to be used.

▼ I find WiFi tethering most useful for shots where the camera is set up in a difficult position. For this real-estate shot, the camera was high up in the air, mounted on a tripod on top of a table. I was adjusting the curtains on the opposite side of the room to modify the light, and it was much easier to observe the effects and fire the shutter from the iPad down on the floor than having to hop up on a precarious table and check the results.

Note: If your camera isn't WiFi enabled , you may still be able to use WiFi tethering via Capture One and its companion app, Capture Pilot. The software costs quite a lot, however, so you'll have to decide if it's worthwhile to your shooting.

TriggerTrap

Off-camera shutter release opens up a world of creative possibilities, and Triggertrap capitalizes on almost all of them. This app really encourages alternative and even extreme approaches to shooting; I recommend browsing the developers' site (www.triggertrap.com) for some inspiration—they show off a lot of impressive images.

Exactly how you end up using it will depend on your shooting style. For a lot of the longer-running apps like the TimeLapse functions, an accessory bracket helps anchor your iPad on a tripod for easy access.

▼ With Triggertrap set up and my camera connected to the iPad, the camera was taking a shot every time it heard a bang over a certain decibel level. That way I got to sit back and enjoy the show without missing any shots!

▼ It's as plug-and-play as you can get. You'll need a dedicated dongle customized for your camera type first, but with that, you need only use it to connect your iPad to the camera, activate Manual Focus on the latter, and fire up the app!

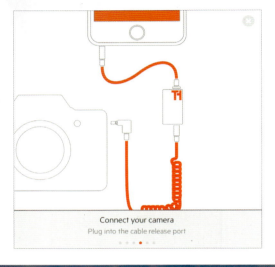

Connect your camera
Plug into the cable release port

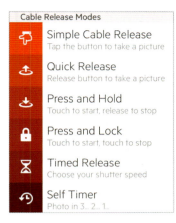

Cable Release Modes

🔻 **Simple Cable Release**
Tap the button to take a picture

🔺 **Quick Release**
Release button to take a picture

Press and Hold
Touch to start, release to stop

🔒 **Press and Lock**
Touch to start, touch to stop

⏳ **Timed Release**
Choose your shutter speed

🕘 **Self Timer**
Photo in 3... 2... 1...

Timelapse Modes

⏱ **Timelapse**
Travel through time

Timelapse Pro
Advanced Timelapse

〰 **TimeWarp**
Timelapse with acceleration

🚫 **DistanceLapse**
Perfect for roadtrips

☆ **Star Trail**
Extreme exposure control

☀ **Bramping**
Bulb ramping timelapse

Sensor Modes

🎙 **Sound Sensor**
Clap, whistle or tap

◎ **Vibration Sensor**
Vibrations and earthquakes

👣 **Motion Sensor**
Detect movement

☺ **Peekaboo**
Facial recognition

▲ These simple Cable Release Modes may already be available in some form on your camera, but it's helpful to have them here as well. Even separating the shutter release from the camera itself can help improve image quality (even minor vibrations from pressing the button on the camera can induce camera shake). And of course, the Time Release and Self Timer allow you to set your own precise time before the shutter fires.

▲ This is probably what I use TriggerTrap for most of all—timelapses. The first option is a basic intervalometer. The TimeWarp changes the interval of the lapse over the course of its duration, so that when the images are played back, it appears to speed up or slow down based on how the interval was adjusted. DistanceLapse uses the iPad's GPS to trigger the shutter at an interval of distance rather than time, so a road trip will play back smoothly at a constant pace. Star Trail uses very long shutter speeds with the intention of combining the shots into a single star-trail shot in Photoshop. Bramping is a portmanteau of Bulb and Ramping, and this function lets you adjust the shutter speed during the time lapse to accommodate for changing exposure conditions (for example a sunset).

▲ The Sensor Modes rely on the iPad's own sensors to trigger the shutter. Sound Sensor is the most basic, and also the one I use the most. It simply monitors the iPad's microphone and fires the shutter when sound over a certain (adjustable) level is detected. Vibration Sensor uses the iPad's accelerometer to monitor vibration, and it's a very sensitive piece of equipment as well. Depending on how you have your iPad rigged up, it can easily detect someone walking across a room (one of the few times where having the iPad loosely secured will improve performance!). Motion Sensor uses the iPad's camera and triggers whenever something enters the frame. Peekaboo uses the iPad's (very good) facial-recognition software to fire only once a certain number of faces are detected in the scene.

HDR Modes

LE HDR
Long exposure HDR sets

LE HDR Timelapse
Long exposure HDR Timelapse

Remote Modes

📲 **Wearables**
Trigger from your wrist

📶 **Wi-Fi**
Trigger remotely

Calculators

◑ **ND Calculator**
Neutral Density Filter Calculator

☀ **Solar Calculator**
Sunrise and Sunset times

▲ These HDR Modes expand on the normal Autoexposure Bracketing function found in your camera, allowing exceptionally long shutter speeds covering a wider EV range. And the LE HDR Timelapse combines this with an intervalometer so that you can bracket every shot in your timelapse, and later combine them so that every image is an HDR shot. This effectively creates HDR video and is seriously impressive to see.

▲ Wearables connect Triggertrap to your Apple Watch and allow you to trip the shutter from there. Wi-Fi allows you to connect multiple WiFi devices running Triggertrap together with a single ad-hoc network, in a Master-Slave setup, so that when the Master unit fires the shutter, all the other devices fire as well. This takes some setting up (and a lot of iOS devices), but can allow you to cover an action shot from every possible angle.

▲ These last features are simply handy extra features that are nice to have. ND Calculator helps work out the correct shutter speeds when using Neutral-Density filters (which you probably will be doing if you're shooting a number of timelapses). Solar Calculator uses the iPad's GPS to tell you exactly when the sun will rise and set on that day, to help make sure you get to the right place in time for the right light.

Duet

This app was a long time coming. One of the first things everyone wanted to do when the original iPad came out was to plug it into their desktop and instantly gain a second screen—and one with a touch interface at that. But something about Apple's walled garden must have made this too complicated because for a long time, the only way to do this was to wirelessly connect the devices, and then the refresh rate was slow, and the lag seriously limited its usefulness.

Fortunately, all that's behind us now, because Duet, launched in late 2014, finally solved whatever the problems were with connecting devices, and made it possible to use the iPad as a powerful secondary screen.

► Setup is remarkably easy: simply install the app on the iPad, and download the corresponding desktop app as well. Once installed, the desktop app will live at the top right of your screen, and clicking on it will pull down a menu of settings, where you can adjust Resolution, Frame Rate, etc. to improve performance. (It's worth noting that this can be demanding on desktop computers that have integrated graphics.)

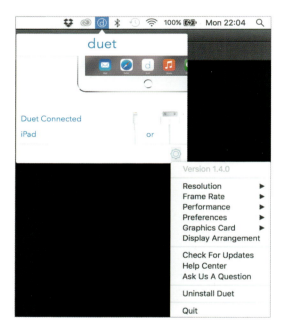

◄ You'll want to go to Display Arrangement (either via the Duet menu on the left or under System Preferences) to position the iPad screen relevant to your desktop. The point is to make sure that when your iPad is to the right of your desktop, and you swipe the mouse off-screen to the right, it shows up on the iPad. (Note that in the example shown, I have the iPad on the right and a secondary monitor on the left —what can I say? I love screen real estate.)

► This menu is found in Lightroom under Window > Secondary Display, and both creates second window (Show) and sets what that window will display. You can then drag the new window over to your iPad (though I find Duet usually pops it over there automatically). I frequently go here to change what the iPad displays based on what I'm doing at any particular moment. For browsing through a large batch of images, Grid view is handy—particularly because at any point you can tap on the iPad and pull the cursor over to that screen (you then have to swipe back over on the desktop to pull the cursor back to the main screen. When I'm developing a photo, I'll switch to one of the Loupe views, as it lets me zoom in to observe the effect of each edit in high resolution on the retina screen.

▼ Note the stylus leaning against the iPad—I hesitate to bring it into the field because I've lost too many of them already, but it really augments the touchscreen experience when working at the desk.

✓ Show	⌘F11
Full Screen	⇧⌘F11
Show Second Monitor Preview	⌥⇧⌘F11
Grid	⇧G
✓ Loupe - Normal	⇧E
Loupe - Live	
Loupe - Locked	⇧⌘↵
Compare	⇧C
Survey	⇧N
Slideshow	⌥⇧⌘↵
Show Filter View	⇧\
Zoom In	⇧⌘=
Zoom Out	⇧⌘−
Increase Thumbnail Size	
Decrease Thumbnail Size	

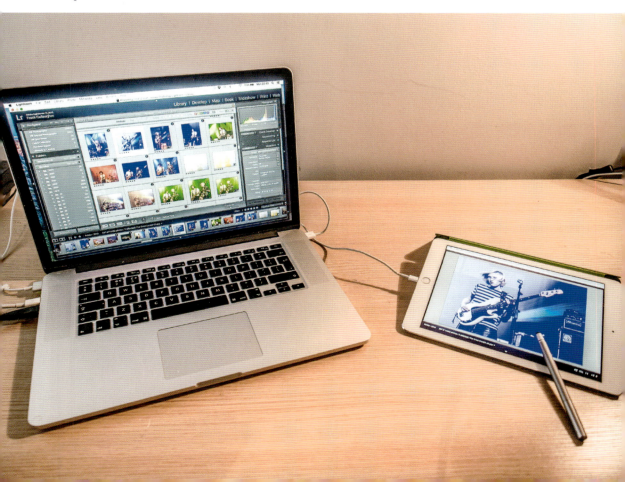

A huge number of apps have been developed for studio photographers over the years, as the iPad has become a standard piece of equipment in many studios. Here I'm just going to cover the top four apps I use the most in-studio, but several more are discussed in Resources on pages 140–141.

500PX RELEASES

Paperwork is a pain, but if you have any intention of making a profit from your model shots, a proper model release is absolutely essential. There's no shortage of model-release apps, but 500px is free and as comprehensive as any I've seen. The idea is incredibly simple: use a template with standard release terms, sign right there on the app, and keep everything cataloged and together on the iPad. The process is also quite a bit less intimidating than the standard paperwork-on-a-clipboard approach. And of course, the app is just as useful for generating Property Releases, which are all too often forgotten about during location shooting.

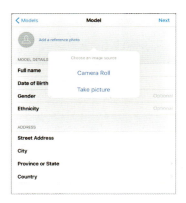

▼ You and the model can then sign the release right there on the iPad, and it's automatically filed within the app. You can also easily export it as a PDF to any number of outlets.

▲ You're prompted to fill out the details of your model, including contact details for future reference. You can even attach the photo itself, which is handy for organization. You'll also be prompted to fill in your own details as the photographer.

▲ Be sure to read through the Terms yourself to make sure they meet your needs. They cover all the basics, but each case is difference. If you want to write your own terms, there are plenty of other apps out there that allow you to customize the legal language.

SOFTBOX PRO

I like this app because it literally turns the iPad into a lighting tool—and why not? It's a portable, mountable device that can emit a specific amount of light of all sorts of colors. Of course, it's no substitute for a meter-wide octobox that can fully light a model from across the room, but for the right applications, it's just the ticket.

◄ The interface is dead simple—choose a pattern, ranging from a checkerboard like this to a spotlight centered in the middle of the screen, and you can even specify the shape of the pattern. Along the bottom of the screen you choose the color, and use the slider to set the brightness.

► I tend to use Softbox Pro as a lightbox for close-up still lifes like this. The background can be set to complement the subject, and the luminosity of the iPad avoids any shadows. The trick is to balance the cool color temperature of the iPad's LCD screen with the ambient light—in fact, I selected the watchface in Photoshop and set a separate White Balance for it.

PHOTO STUDIO LIGHT SETUP

Elaborate lighting setups require a lot of planning, both for the photographer's creative brainstorming process, and also the collaborative aspect of instructing assistants how to properly arrange the various elements of the shot. All too often, these setups are scribbled with pen and ink, but Photo Studio Light Setup puts the entire process into a very slick interface, with loads of customizability and professional organization.

▼ The comment box can be populated by selecting from a fairly comprehensive list of equipment and settings, with space for additional notes at the bottom.

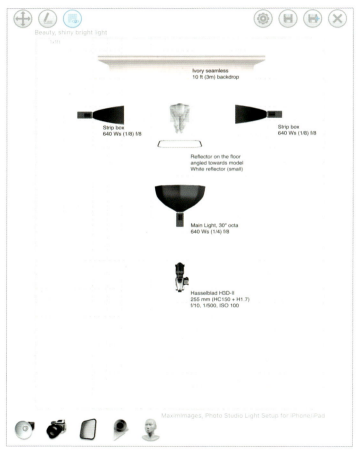

▲ The process simply entails dragging an element (light, camera, reflector, backdrop, or subject) from the panel at the bottom of the screen into place in the grid above. Every element of the setup can be positioned, rotated, and commented upon.

HELIOS

On the subject of lighting, I can't skip over one of my favorite apps. Of course, this has more to do with location shooting than in-studio shoots, but it's so useful I really want to make sure it's covered. Helios is the most comprehensive sun-tracking app I've found. It can tell you the precise position of the sun in the sky any time of the year, past, present, or future. It's become a staple of my location-scouting routine, allowing me to easily visualize a shot, and then find the exactly right time and place to be in order to achieve what I want. I regularly pull it out when I see an interesting scene, just to gauge the location's future potential.

► The Heliometer panel shows you the exact degree of elevation at specific times. You can also pull up thorough Azimuth and Altitude tables, with Shadow ratios for the whole day, divided into five-minute increments, based on your location, which itself is automatically pulled up by the iPad's GPS.

◄ Of course, the coolest feature is the Virtual Sun panel. Here, you start by calibrating the app by taking a picture pointed right at the sun (mind your eyes, but the camera will be fine). You can then hold up the iPad to a scene and see the path of the sun projected across the sky. How many times have you wished the sun was in a slightly different position to achieve the perfect sunset shot? With this, all you have to do is adjust the date to see when your ideal shot will occur. Then make a note, and return when the app tells you to; simple as that! It's an exercise in patience, to be sure, but it's also a massive time-saving device.

Sharing Photos

Sharing has been only a tap away from almost everything we've covered in this book, but it's also the ultimate step that follows all the shooting, organizing, and editing we've worked through, so it's time to talk about it comprehensively.

We'll get under the hood of the Share feature, so you know what it's doing and how it's accessing your photos, and how to share those photos to particular outlets. One of the most important of those outlets is, of course, the online gallery, so we'll also go over how to assemble and publish a collection of your best work. Finally, we'll use the iPad to build a professional-quality portfolio, something the iPad absolutely excels at, and something you'll be proud to show off.

The Share Function

That little Share icon has been with us almost every step of the way through this book, and for good reason—it's part of the iPad's ethos to be connected every step of the way, and to facilitate sharing, along creative outlets just as easily as social-media ones.

What you see now, though, is the product of lots of revision and evolution by Apple. The original Sharing function was extremely basic—you could send a photo via Mail, and little else. Then, for a long time, the Share menu was restricted to Apple's own services. But Apple took a big step when they opened up the platform to third-party developers and permitted their apps to appear natively in the Share menu across the board, regardless of which particular app you're in at any given moment.

This has worked extremely well, and is one of the main ways around iOS's lack of a straightforward file-management system. You can import a photo to Photos, "share" it (really, copy it) to Snapseed for editing, then put that edited photo directly into an iMessage to a friend. An important part of this is, of course, security; Apple had to open up its ecosystem in order to accommodate all this inter-app sharing, and that's quite at odds with Apple's walled-garden approach. The compromise was a comprehensive permissions procedure, in which you explicitly permit which apps can access which parts of the walled garden (for our purposes, it's usually Photos). You'll be prompted to grant permission (which is sometimes a multi-step process) the first time you use that particular app's Share feature.

▼ Here you see the three levels of the standard Sharing panel: AirDrop (pages 40–41) at the top, permitted apps along the second row, and build-in features on the third row. It's worth noting that Dropbox made it into the built-in third row only through rigorous cooperation with Apple—you won't find many other apps there.

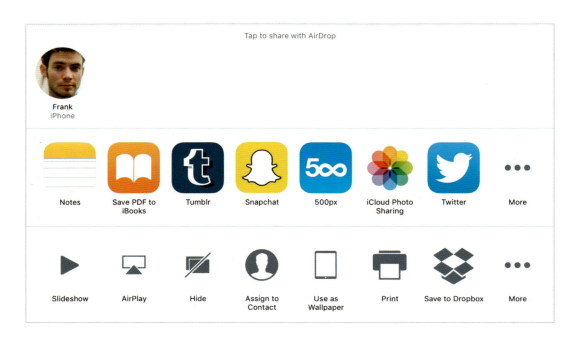

▼ By scrolling right along the second row in the Share panel and tapping More, you'll pull up this Activities panel, showing all the available apps. You can at any point deactivate an app's Share abilities by tapping on its corresponding switch. You can also see that the three Apple apps—Message, Mail, iBooks, and iCloud are permanently activated.

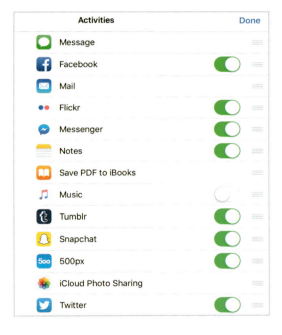

▲ This list can become quite lengthy as you build up your apps, so by tapping and holding on the far right of each app's entry, you can move it up or down in the list. This is very useful as you can organize the menu to prioritize your most-used apps.

► You'll have to set up a mail account in Settings in order to use the Mail feature, but it's useful for straightforward, old-fashioned sharing via email. By default, you'll be sending a full-size JPEG, with the size displayed along the Cc/Bcc line at the far right. Tapping on that will pull up an Image Size menu, where you can select different image sizes, which is particularly useful if you're sending multiple images (too many and the email won't go through).

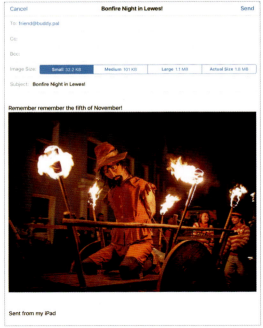

Creating Online Galleries

The preceding pages cover sharing on a case-by-case basis, but once you've worked on a batch of images, it's far easier to create a complete gallery online and invite viewers to visit it rather than sending a giant archive to specific recipients. Back on pages 36–39, we discussed iCloud Photo Sharing, which effectively allows you (and others) to tap into your Apple ecosystem's Photos feature from a browser. It's by far the easiest way to share

a gallery. With a photo enlarged to fullscreen, you can use the Comments tab at the bottom to write captions or titles (or tell a longform story about the shot if you like). It's pretty clear that Apple designed these galleries for casual sharing among friends and family, but if you curate your album properly, there's nothing to keep you from sending a link to a client. Of course, if you want fully professional results, there's another option...

▲ ▶ You can also interact with your iCloud galleries via the desktop Photos app, under the Shared tab. To add new photos from your desktop (once they've been properly Raw processed and finished), in the Photos app, go to File > Import, and locate the images in Finder. At this point, your newly imported photos will be shared across your iOS devices (that have Photo Sharing enabled), but they won't be shareable. For that, you need to click the Share icon in Photos just like in iOS, select iCloud Photo Sharing, and Add to a Shared Album.

LIGHTROOM MOBILE

Back when we talked about creating Collections for Lr Mobile (pages 86–89), I said it was silly that to transfer the photos a few inches from your desktop to your iPad they had to go all the way to the web and back first. Well, there is a side benefit of that, which is that every collection you sync with Lr Mobile exists as a gallery waiting for you online. Don't worry, it's private by default, and an amazing (and relatively unadvertised) feature is that there's no storage limit at all— your Lr Mobile collections don't count against your Creative Cloud storage allotment.

▲ In Lightroom, under the Collections panel on the left, if you right-click on a collection, you'll see Lightroom mobile Links, where you can either click on View on Web to go to the gallery, or Make Collection Public to broadcast it straight from the app.

▶ To share the Collection with others, click Shared, then expand the menu by clicking on Options. You'll be given a shortened URL that you can send to as many people as you like, or you can click Embed to get the code needed to paste into your own website if you like. You also have options to share directly to Facebook, Twitter, and Google+. Further, you can choose whether to show all the images in the Collection, or specify only those that are Picked, Unflagged, or Rejected. And best of all, you can check Allow Downloads, and make the best use of the free storage space. This allows anyone with the URL to download a large (2048 pixels long) JPEG. And that download process is actually using Adobe's Raw processing engine to generate the JPEGs, because remember, what's being stored in Creative Cloud are just Smart Previews of your photos alongside metadata reflecting any adjustments you've made.

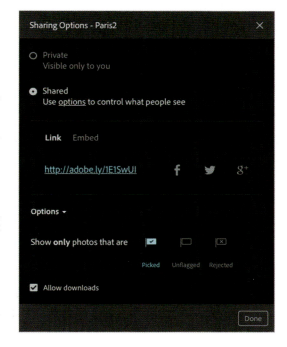

◀ In the shared collection gallery, anyone with the link will see a grid view by default, and can click on an image to pull up a full-screen view. Doing so also pulls up two panels on the right of the screen. The Activity panel (left) allows viewers to Favorite images and write comments (to which you can respond—this collaborative aspect is on of the best features of these online galleries). The Photo Info panel (right) shows EXIF data, and offers the Download button (provided you've checked Allow Downloads for the Collection in the Sharing Options menu).

Portfolio with Foliobook

Particularly once the retina screen arrived, the iPad was immediately seen as an obvious choice for displaying a portfolio of your finest work. It's portable enough to slide across a table, the interface makes it easy to browse through a collection, and really, the screen—it's all about the screen. Needless to say, if you're making a portfolio, you should make it on the iPad. Toward that end, you should also use the best app available to show off your work, and to me, that definitely means Foliobook. This is a svelte, consummately professional app that has loads of customizability under the hood, so let's take a closer look.

▼ This is the finished product I'm walking you through now. The basic structure is: Landing Page featuring a Title and multiple Galleries, each of which contains images of a particular type.

▲ From the home screen, double tap to pull down the menu at the top of the screen, and tap Portfolio.

▲ Here you can add or arrange your portfolio's constituent galleries. Tap on an entry to adjust that particular gallery.

▲ Here you can title each Gallery, adjust how the title will appear on the Landing Page, and also add photos directly from a Dropbox folder. This is also where you can delete a gallery if you like.

▲ Next, tap on the Pen icon in the top menu (by double tapping on the Landing Page). Here you can design all the aspects of this Landing Page—these menus basically comprise a graphic-design workflow, but are simplified enough to ensure good results.

▲ First you pick either an image or a video for both the Landscape and Portrait orientations (the fact that you get a different image depending on how you hold the iPad is really neat, I think. Remember to think critically about these choices—these aren't just your favorite photos; these need to graphically fit in the space, and be able to accommodate the Title and Gallery Names in an easily viewable way.

▲Titling is usually either your name or the name of your business. The Font Size needs to let your Title fit into the right space within your selected background image. You're able to adjust the position of the Title differently for Landscape and Portrait orientations.

▲ Here you can set the Title's color. This is a rather unintuitive interface, insofar as you're actually manually setting the RGB value, so unless you have all 16.8 million possible RGB color values memorized, you're just going to have to play around with the sliders until you find a color that suits both your taste, and complements both of the background photos.

◄ Next is the Font selection. I like to keep it harmonious with the feeling of the rest of the iPad, so I used HelveticaNeue, but there are plenty of other options to explore here.

◄ And here you can choose the position of your Title and Gallery text on top of the background images. I highly recommend choosing the third option, as this allows you to freely position your galleries. The goal here, like the position of the Title, is to use your photo graphically, and position text in a way that "fits," both in terms of physical space, and also color and other distractions. Using the example opposite, I specifically chose this image because I could see the Galleries would fit well on the wall at the bottom left, and the Title would fit into the sky easily.

DESIGNING YOUR GALLERIES

The design process continues in the galleries, though it's not quite as graphically intensive as the Landing Page. This is more about cultivating the proper experience, via transitions, magnifying abilities, even music (if appropriate). And of course, this is also where you'll add your images, which should already have been through several rounds of critique. Ideally, you have a folder of properly formatted portfolio-ready images already prepared and waiting.

▲ Let's start with the Styling menu. Again, this is indicated by a Pen icon at the top of the screen.

▲ ► Here you can enable the sidebar menu, which contains the options shown at right.

Playback: Initiate Autoplay. This will turn to a Pause button once playback begins.

Return: Takes you back to the Landing Page.

Lightbox: A valuable feature where viewers build and share their own gallery of your photos.

Share: Here you can share a screenshot directly to Twitter or an Email.

Filmstrip: Pulls up a filmstrip view along the top of the screen.

Slideshow Tips: Pulls up a set of instructions showing gesture controls.

▲ Your transitions are largely a personal choice, but I would recommend choosing somewhere in the middle—too fast and there won't be time to appreciate the photography; too slow and the viewer won't realize it's on Autoplay and will likely start swiping through on their own.

► Under Preferences, you can set the position of your filmstrip view (Thumbnails), and choose whether they display captions. You can also deactivate zoom, in case you want to keep a certain detached viewing experience (not a bad idea—remember, a portfolio is different than a gallery). You can also include a watermark if you like, or choose to strip out the metadata of your shots.

◄ Back to the top-level menu, tapping on the A will pull up options to add Captions, Descriptions, and Copyright info to each image in a gallery. Personally, I think this isn't necessary for a portfolio, though I can only speak for my own personal experience; I'm sure there are clients who want to hear the full backstory and details behind each shot. I bring this up simply to reiterate that this isn't a normal image gallery, so don't feel the need to make a detailed slideshow of every single shot from you recent vacation. This needs to be a refined, professional expose of your skills, not just a collection of pretty images.

▲ Tapping on the musical-note icon allows you to add a music track (from music files already stored locally on your iPad). This can be nice, but only for specific uses. Most of the time, a portfolio review isn't a slideshow, and you don't need to set a music track.

◄ Finally tap the + sign to add photos to each gallery. You can add from the Photos app, or import directly from Dropbox or PhotoShelter.

► If you have your selections already organized into albums in the Photos app, you can simply tap the Folder icon to import the whole album in one fell swoop.

◄ This might actually be too many images for a single gallery. It would be wise for me to return to this gallery later on and have a culling of anything that isn't the absolute best representation of my abilities. And then do that again, and again, until I've distilled my selection down to something that is guaranteed to impress a client.

Resources

That just about covers it! At the end here, I've included a couple of lists of accessories and apps that didn't quite make it into the body of the book, but which are well worth investigating. Particularly the accessories, as I consider almost all of these essential to getting the most out of the iPad. My list of apps are far from comprehensive, but as I've said several times, there are so many to choose from (and so many Top Ten lists online to peruse) that here I want to offer just a few that have found their way onto my iPad and into my workflow because of one exceptional feature or another.

Recommended Accessories

SEAGATE WIRELESS PLUS

I definitely want to start this Accessories list with a backup option, as it's an essential part of the workflow I've been describing throughout this book. There are many wireless external hard drives, and new models are released every year, but at time of writing, I heartily recommend the Seagate Wireless Plus. Like most of these WiFi drives, it uses its own (free) app to connect to the drive and allow transfer of files—and they can go in both directions, so you can load this up with media if you're traveling as well.

BELKIN FLIPSTAND ADJUST

While I think the magnetic Smart Covers that Apple sells with the iPad are a brilliant piece of engineering, they're not nearly sturdy enough for prolonged interaction—particularly in their upright configuration. I'm a fan of the Belkin Flipstand, as it's portable, so it comes with me on the road, but also sturdy enough that it sits on my desk just fine when I'm back at home (using it to prop up the iPad while it's a secondary display, via the Duet app—pages 120–121).

STYLUS—APPLE PENCIL OR ADONIT JOT TOUCH

I'm a fan of the Adonit Jot Touch because it offers pressure sensitivity (built-in and transmitted to the iPad via bluetooth) and customizable buttons. If you're working on an iPad Pro though, it really makes sense to spend a bit more and get the Apple Pencil, as it makes full use of the Pro's screen features. Regardless of the model type, a stylus really will help give you a great deal of control when you need to position an editing slider to just the right point, or line up a crop to a precise degree.

TECHLINK RECHARGE

A lot of what we've discussed in this book will eat through your battery life with lightning speed, so a portable charger is an absolute must, at least if you're working in the field. I think we all know the stress of seeing that battery indicator drop into the red when you're in the middle of a task. Again, there's no shortage of options, so feel free to find the best deal, but I like the Techlink Recharge 2500 because it's tiny, and can charge up the iPad multiple times before it's depleted, and its own charge is indicated by an LED panel.

PARROT BEBOP

Drone photography is a bit outside the scope of this book, and this is easily the most expensive accessory on this list, but I really want to at least mention what's possible here. The Parrots are incredibly popular for a good reason: while simple to control (entirely from the iPad via a free companion app), the world of aerial photography that they open up is unparalleled. This is seriously cutting-edge stuff, with stabilized high-quality 1080p video and still images that you would've never dreamed of capturing before. But the real point is: these drones are fun! If you have the means, I highly recommend trying one out.

KEYBOARD—LOGITECH KEYS-TO-GO OR APPLE SMART KEYBOARD

I also have the standard Apple Bluetooth keyboard, but this one from Logitech is noticeably smaller, and the key action works just fine for me. This may be a leap for some of you though—very little of what we've covered require extensive typing of any sort. Of course, if you have the iPad Pro, you'll almost certainly want to splurge and get its companion Smart Keyboard (that doubles as a cover).

Recommended Apps

AUTOSTITCH PANORAMA
This is the best app I've found for stitching together multiple images into a panorama, and it's not limited to the iPad's camera—you can import and assemble images from the Photos app just as easily.

GEOTAG PHOTOS PRO
This app automatically logs your GPS location for a set period of time, and then syncs that data with Shuttersnitch, allowing you to add GPS data to a batch of photos (JPEG only, sadly).

ADOBE PHOTOSHOP MIX
This is possibly the only way to work on separate layers of a Photoshop PSD file on the iPad. And this being Adobe, once you've combined your images, you can sync with Creative Cloud easily.

GARAGEBAND
If you find yourself really in tune with iMovie, you'll probably want to explore Apple's free music-creation app as well. It's been a longtime favorite and is feature-packed, especially for the price!

ADOBE REVEL
Unlimited cloud storage and a very slick interface make this worth checking out, and Adobe's working hard to promote this sharing and storage service by adding new features quite frequently.

DOFMASTERS
I've had this depth-of-field calculator app forever, and use it whenever I really need to know exactly what I'm getting in focus. Simple, steamlined, and functional.

FLICKR
Flickr had dropped off my radar until they gave all users a terabyte of free storage (though it's not compatible with Raw files). Free is very hard to say no to, and it boasts an impressively active community.

INSTAGRAM

I doubt I'm the first one to tell you about Instagram, but it's really worth pointing out that if you work on your images to the professional degree we've covered in this book, and then share them on Instagram like everyone else does their snapshots, you invariably get a lot of attention. Whether social media is your thing or not, I leave up to you; but it's worth noting that many photographers have made a name for themselves purely through Instagram popularity.

ADOBE PREMIERE CLIP

Whereas iMovie can only apply global filters to video clips, this app lets you actually adjust the exposure manually, with separate sliders for Exposure, Highlights, and Shadows.

PHOTOGENE

This app just barely didn't make the cut in the Editing chapter (because Snapseed is so good), but it's a highly competent image editor in its own right, with familiar controls you may prefer.

CAROUSEL

With all that I use Dropbox for, it's a natural step to also make use of their social-media sharing service, with automatic uploads that organize my photos and free up storage on my iPad as well.

EASY RELEASE

This is a more comprehensive model-release app than the one discussed on page 122, offering customizable release forms and branding options for a personal touch.

SMUGMUG

Smugmug has been a great professional resource for sharing images as well as ordering prints, and this app plugs easily into your existing account to sync their services with your photos.

ACTIONS

You can turn your iPad into a customizable control pad with this app. Setting it up takes a while but is well worth the investment, as you can build controls for a huge variety of desktop apps.

Index

Acknowledgments

Thank you to the talented team at Ilex Press, specifically—
Adam Juniper for commissioning this book, Roly Allen for
finding its audience, Rachel Silverlight and Julie Weir for
guiding it through, Zara Larcombe and Natalia Price-Cabrera
for being a joy to work with all the while, Pete Hunt for his
production expertise, and the inimitable Ginny Zeal for the
beautiful design. And, of course, thank you Mom and Dad,
as always.